THREE KINGS
TEN MYSTERIES

GRZEGORZ GÓRNY

THREE KINGS
TEN MYSTERIES

The Secrets of Christmas and Epiphany

Previous page
(title): *Dream of the Magi,* twelfth-century sculpture by Gislebertus, capital in Cathedral of St. Lazare, Autun, France.

Illustration based on detail from the *Catalan Atlas.*

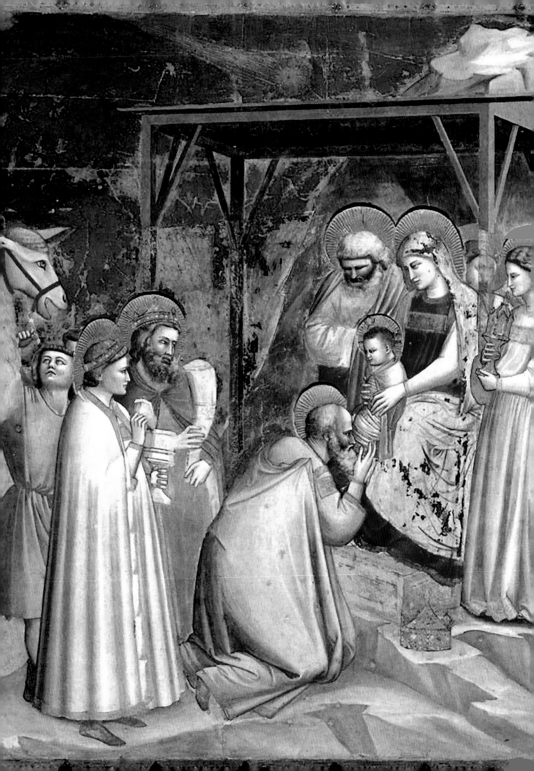

PROLOGUE

TRUE OR FALSE?

True or false? Reality or fiction? Today, the story of the Three Kings is not only part of Christian tradition, but also part of contemporary culture. For centuries it was a governing theme in works of art. The scene in which the Magi kneel before the Infant in Bethlehem has been reproduced in paintings, in wood and stone sculptures, in poems, in stories, and in film. The Feast of the Epiphany, celebrated on January 6, is not only an important Church festival, but also a public holiday in many countries.

What lies at the heart of this feast day? Do we recall actual events, or are we swayed by the allure of legend and the power of myth? Did the scene known as the Adoration of the Magi really take place, or is it the stuff of religious imagination? In attempting to answer this question, we must retreat to the depths of history, where we encounter a series of mysteries that date back to the dawn of our civilization. It is worth confronting this challenge and penetrating history's secrets, in order to come closer to the truth hidden behind numerous contradictory hypotheses.

Matthew the Apostle writes in his Gospel that the strangers from the East were led by a star, which many commentators have interpreted as a symbol of enlightenment, or edification of the mind. Let our guides in this investigation therefore be people of learning, representatives of both science and the humanities, for it is their discoveries that have shed new light on these evocative events.

7

Adoration of the Magi, Giotto di Bondone (1267–1337), the Scrovegni Chapel, Padua. A comet can be seen flying over the stable. The artist was most probably inspired by Halley's Comet, which he saw in 1301.

The phantom
Apostle

1

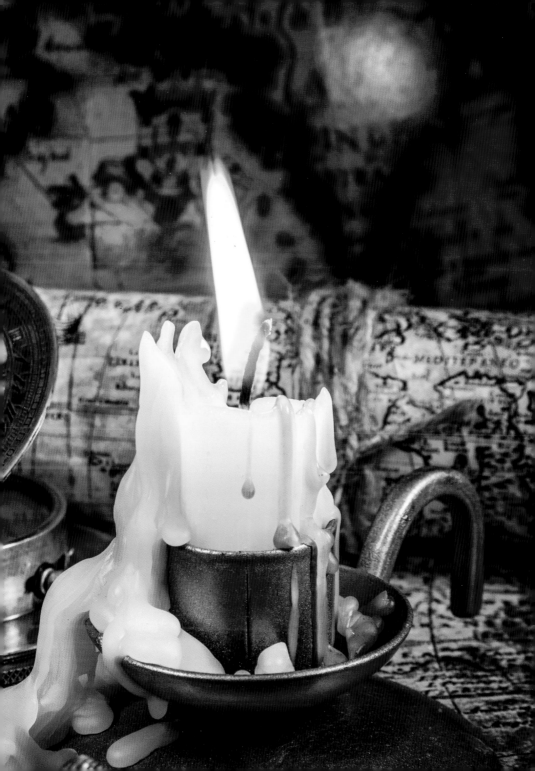

FIRST MYSTERY

THE PHANTOM APOSTLE

It is difficult to imagine a greater contrast: thousands of works of art on the one hand; barely a couple dozen sentences on the other. The story of the Three Kings is capable of giving rise to whole libraries, a collection of sculptures, or a gallery of paintings. Yet it is based on a single textual source, found in the second chapter of the Gospel according to St. Matthew. This is the only place in the New Testament that makes reference to the Adoration of the Magi. It is worth quoting the relevant passage in full.

Publican collecting taxes, Roman relief carving.

Now when Jesus was born in Bethlehem of Judea in the days of Herod the king, behold, Wise Men from the East came to Jerusalem, saying, 'Where is he who has been born king of the Jews? For we have seen his star in the East, and have come to worship him.' When Herod the king heard this, he was troubled, and all Jerusalem with him; and assembling all the chief priests and scribes of the people, he inquired of them where the Christ was to be born. They told him, 'In Bethlehem of Judea; for so it is written by the prophet:

"And you, O Bethlehem, in the land of Judah, are by no means least among the rulers of Judah; for from you shall come a ruler who will govern my people Israel."'

"Then Herod summoned the Wise Men secretly and ascertained from them what time the star appeared; and he sent them to Bethlehem, saying, 'Go and search diligently for the child, and when you have found him bring me word, that I too may come and worship him.' When they had heard the king they went their way; and behold, the star which they had seen in the East went before them, till it came to rest over the place where the child was. When they saw the star, they rejoiced exceedingly with great joy; and going into the house they saw the child with Mary his mother, and they fell down and worshiped him. Then, opening their treasures, they offered him gifts, gold and frankincense and myrrh. And being warned in a dream not to return to Herod, they departed to their own country by another way" (Mt 2:1–12).

The story of Herod continues with the infamous massacre:

St. Matthew the Evangelist. The author dips his quill in an inkwell held up by an angel, thereby drawing inspiration to write God's work.

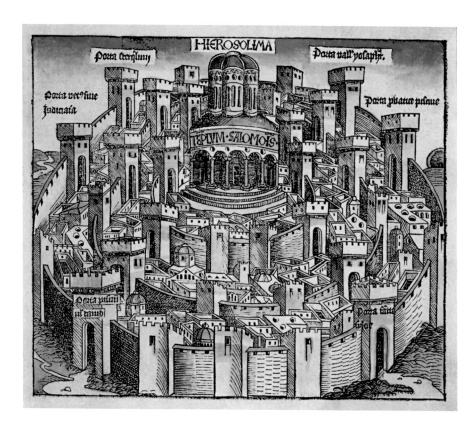

View of Jerusalem from Hartmann Schedel's *Nuremberg Chronicle*, 1493.

"Now when they had departed, behold, an angel of the Lord appeared to Joseph in a dream and said, 'Rise, take the child and his mother, and flee to Egypt, and remain there till I tell you; for Herod is about to search for the child, to destroy him.' And he rose and took the child and his mother by night, and departed to Egypt, and remained there until the death of Herod. This was to fulfil what the Lord had spoken by the prophet, 'Out of Egypt have I called my son.'

"Then Herod, when he saw that he had been tricked by the Wise Men, was in a furious rage, and he sent and killed all the male children in Bethlehem and in all that region who were two years old or under, according to the time which he had ascertained from the Wise Men. Then was fulfilled what was spoken by the prophet Jeremiah:

'A voice was heard in Ra'mah, wailing and loud lamentation, Rachel weeping for her children; she refused to be consoled, because they were no more'" (Mt 2:13–18).

The fact that an historical account can be traced to only one source does not mean it lacks credibility. There are many examples of historical facts having been related by a sole historian (Herodotus, Tacitus, Josephus), and yet no one has questioned these accounts simply because they happen to be unique.

As the German theologian Klaus Berger wrote: "Even when only one piece of evidence exists ... we must – until proven otherwise – accept that the evangelists wouldn't have intended on misleading their readers, and based their writing on historical fact.... Questioning the historicity of this text purely out of mistrust goes against every conceivable aspect of the historian's competency."

Since the account concerning the Adoration of the Magi has just one author, it would be worth finding out more about him, and the reliability of his story. Who was St. Matthew?

American writer and historian C. Bernard Ruffin calls him the "phantom apostle", since we know very little about him. The other three Gospel writers provide a brief account of his calling and subsequent conversion. Matthew himself has little to say on the subject: "As Jesus

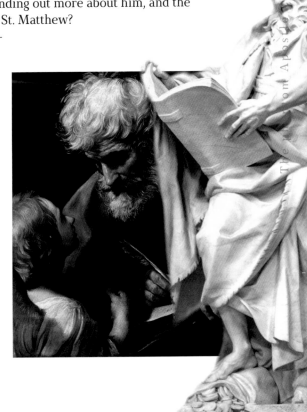

St. Matthew and the Angel, by Guido Reni, painted 1635–1640. Currently held in the Vatican museums.

Statue of St. Matthew in the Roman Archbasilica of St. John Lateran.

Publican and public sinner

St. Matthew is described in the Gospels as one of the individuals who, through Jesus' influence, completely changed his way of life.

JESUS WELCOMES INTO THE GROUP of his close friends a man who, according to the concepts in vogue in Israel at that time, was regarded as a public sinner.

Matthew, in fact, not only handled money deemed impure because of its provenance from people foreign to the People of God, but he also collaborated with an alien and despicably greedy authority whose tributes, moreover, could be arbitrarily determined....

The good news of the Gospel consists precisely in this: offering God's grace to the sinner!...

Thus, in the figure of Matthew, the Gospels present to us a true and proper paradox: those who seem to be farthest from holiness can even become a model of acceptance of God's mercy and offer a glimpse of its marvelous effects in their own lives.

Pope Benedict XVI

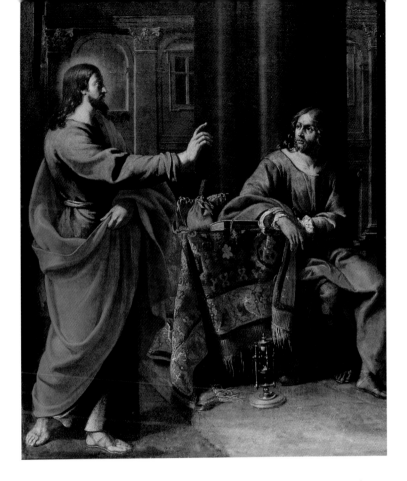

Follow me. Painting of the Flemish School in the collection of the National Museum in Warsaw.

passed on from there, he saw a man called Matthew sitting at the tax office; and he said to him, 'Follow me!' And he rose and followed him" (Mt 9:9).

In their accounts, St. Mark and St. Luke add that the tax collector was called Levi. Like the other Apostles, he therefore had two names: the Greek Matthew (meaning "gift of God") and the Jewish Levi (after the patriarch who founded one of the twelve tribes of Israel). St. Mark also writes that Matthew was the son of Alphaeus, and therefore the brother of James the Less, who

15

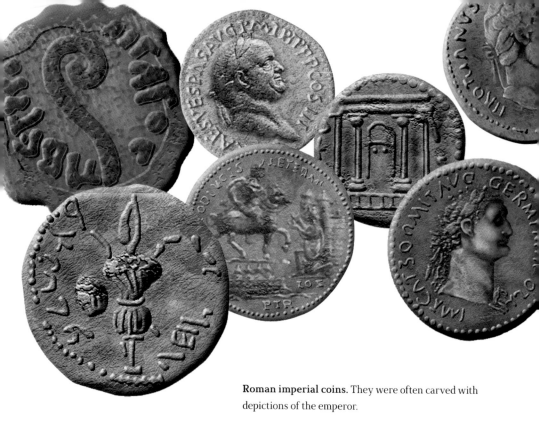

Roman imperial coins. They were often carved with depictions of the emperor.

was also one of the twelve Apostles. The brotherly ties shared by Matthew and James (like those of Peter and Andrew, and John and James the Great) go some way in explaining the circumstances of Matthew's calling. He must already have known Jesus, and his decision to follow him would have resulted from previous meetings, discussions, and considerations.

Matthew was a tax collector in Capernaum. He therefore collaborated with the occupying Roman forces. C. Bernard Ruffin explained: "Roman taxation was handled by wealthy businessmen who paid a set fee for a contract to collect taxes in a specific jurisdiction. The tax contractor, or publican, was assigned a certain amount of money to collect within a given time. If he failed to raise the sum that his jurisdiction was assessed, he had to pay the deficit out of his pocket. Any excess, however, he was allowed to keep. Thus the Roman system of taxation lent itself to grave abuse.

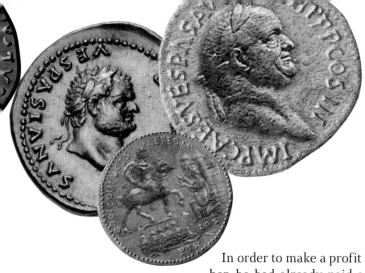

In order to make a profit (remember, he had already paid a sum for the privilege of collecting taxes) the publican had to demand more revenue than the government actually required. Ordinary people knew this and resented anyone connected with the internal revenue service of the day."

Jews therefore despised tax collectors for two reasons: for being collaborators in the service of occupying forces, and for being extortionists and swindlers, cheating their own people. Evidently Matthew must not have felt too comfortable in this role, since he gave up his well-paid job in favor of an uncertain future, following a wandering preacher.

St. Luke describes how, following his conversion, Matthew organized a lavish feast in Capernaum in Jesus' honor. This elicited protestations from the Jewish community leaders, who were appalled by the fact that a Nazarene and his followers would deign to eat and drink with sinners and publicans. Their outrage was met with a short riposte from Christ; "Those who are well have no need of a physician, but those who are sick; I have not come to call the righteous, but sinners to repentance" (Lk 5:31–32).

We know little of what happened to Matthew following his calling. St. Paul doesn't speak of him in his letters; neither does St. Luke in the Acts of the Apostles. This would suggest that their paths didn't cross, and therefore that Matthew probably didn't conduct his missions in the vicinity of the Mediterranean. Traditionally, he was supposed to have spread the word in Ethiopia and Persia. It is unknown, however, how or where he died. Some, like

17

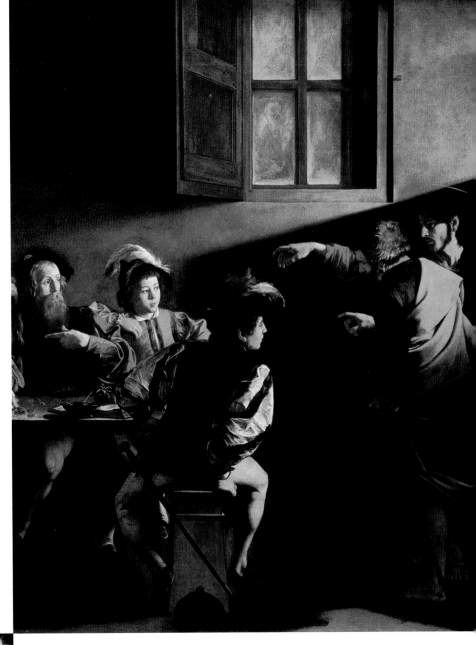

The Calling of St. Matthew (fragment) by Caravaggio, painted 1598–1600 for the Roman Church of St. Louis of the French.

Pen and inkwell, such as would have been used within the Roman Empire in Jesus' day.

St. Clement of Alexandria, claimed that he lived to an old age and died of natural causes; others, such as Abdias, an author of an apocryphal apostolic history, maintained that Matthew was martyred in Ethiopia.

Matthew is known primarily as one of the Four Evangelists, a fact confirmed by the Church Fathers. A paucity of source material means we do not know when or where he wrote his Gospel. There is no consensus among experts on this matter. Currently, there is a debate among Bible scholars concerning the language in which the Gospel was first written: Aramaic, Hebrew, or Greek.

An account by Bishop Papias of Hierapolis, a martyr and Apostolic Father who lived from 70 to 163 AD, suggests that Matthew transcribed Christ's *logia* ("words" or "sayings") in Hebrew (which is treated by some as synonymous with Aramaic), which then formed the basis for a translation into Greek. Protestant scholar Henry Clarence Thiessen argued that Matthew wrote his Gospel in two different languages, making it analogous to Josephus' *Jewish Wars*. Leaving this inconclusive debate to one side for now, it would be worth examining the predominant characteristic feature of Matthew's Gospel. It would seem that his writing was directed mainly at a Jewish audience, linking Old Testament prophecies with their fulfillment in the life of Jesus. Indeed, fulfilled messianic prophesies are mentioned no fewer than thirteen times. The American Bible scholar Floyd V. Filson has noted: "The atmosphere of this Gospel is such as to have a special point for those who had come from Judaism and needed assurance that the Christian gospel not only fulfilled the Old Testament promises, but also gave the full statement of the will of God on points where the Old Testament law was inadequate."

19

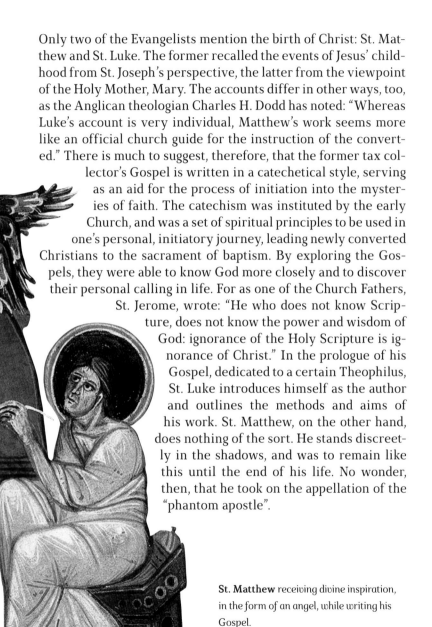

Only two of the Evangelists mention the birth of Christ: St. Matthew and St. Luke. The former recalled the events of Jesus' childhood from St. Joseph's perspective, the latter from the viewpoint of the Holy Mother, Mary. The accounts differ in other ways, too, as the Anglican theologian Charles H. Dodd has noted: "Whereas Luke's account is very individual, Matthew's work seems more like an official church guide for the instruction of the converted." There is much to suggest, therefore, that the former tax collector's Gospel is written in a catechetical style, serving as an aid for the process of initiation into the mysteries of faith. The catechism was instituted by the early Church, and was a set of spiritual principles to be used in one's personal, initiatory journey, leading newly converted Christians to the sacrament of baptism. By exploring the Gospels, they were able to know God more closely and to discover their personal calling in life. For as one of the Church Fathers, St. Jerome, wrote: "He who does not know Scripture, does not know the power and wisdom of God: ignorance of the Holy Scripture is ignorance of Christ." In the prologue of his Gospel, dedicated to a certain Theophilus, St. Luke introduces himself as the author and outlines the methods and aims of his work. St. Matthew, on the other hand, does nothing of the sort. He stands discreetly in the shadows, and was to remain like this until the end of his life. No wonder, then, that he took on the appellation of the "phantom apostle".

St. Matthew receiving divine inspiration, in the form of an angel, while writing his Gospel.

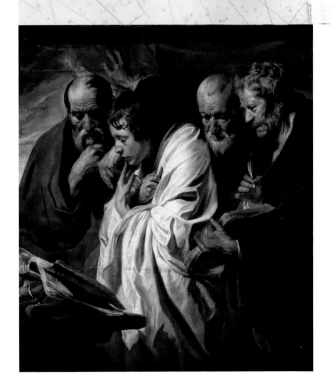

You can't serve God and mammon

HE WORKED AS A TAX COLLECTOR. He could write and count, which were not widespread skills in those days. He recorded revenue, filled out monotonous ledger columns: forename, surname, amount owed, credit. He counted cash. He probably wasn't liked. He was, after all, an employee of the occupiers. Such people are always suspected of dishonesty and treachery.... He became one of the Twelve. He wrote a Gospel. In effect, he returned to writing. But this time instead of calculating sums, he wrote words filled with life.

Fr. Tomasz Jaklewicz

The Four Evangelists, by Jacob Jordaens, painted around 1625–1630. Currently held in the Louvre, Paris.

The Gospel's
veracity

2

HE GOSPEL'S
ERACITY

the Gospels reliable? Can we believe the
s of Jesus' birth and childhood, as related to
St. Matthew and St. Luke? Since Matthew
tax collector, he must have had fairly spe-
d knowledge of financial affairs. Indeed,
rs point out that he is very precise when it
to these matters. He uses terms like "tax",
e", and "interest", and he understands their
ary value.

He knows also that a laborer's daily wage was one denarius, and that a tax collector's booth was located near Capernaum.

To this day scholars have been unable to discover anything that would contradict the information contained in Matthew's Gospel. We might do well to consider the opinion of American archeologist John McRay: "So far, archeologists haven't found anything that would conflict with Biblical accounts. On the contrary, archeology has revealed the falsity of numerous views professed by scholarly skeptics, which for years were acknowledged as fact." The American archeologist and rabbi Nelson Glueck claimed quite simply: "It may be stated categorically that no archeological discovery has ever controverted a Biblical reference."

In the nineteenth century, it was common for academics to question the credibility of numerous events described in the Gospels. They were often regarded not so much as historical facts, but rather as an expression of the imaginary hopes and desires of the early Christian communities. The author whose credibility was questioned most frequently was St. Luke. The story of Christ's birth was the passage most often cited as a particularly outstanding example of historical chicanery and factual avoidance:

"In those days a decree went out from Caesar Augustus that all the world should be enrolled. This was the first enrollment, when Quirin'ius was governor of Syria. And all went to be enrolled, each to his own city. And Joseph also went up from Galilee, from the city of Nazareth, to Judea, to the city of David, which is called Bethlehem, because he was of the house and lineage of David, to be enrolled with Mary his betrothed, who was

Vessel from Qumran,
in which the Essenian papyrus scrolls were kept.

Flavius Josephus, renowned Romano-Jewish scholar and historian, author of works including *Jewish Antiquities* and *The Jewish Wars.*

with child. And while they were there, the time came for her to be delivered. And she gave birth to her first-born son and wrapped him in swaddling cloths, and laid him in a manger, because there was no place for them in the inn" (Lk 2:1–7).

Even as late as the nineteenth century, scholars believed that this census was actually invented by Luke, as he is the only Evangelist to make any mention of it. Critics also pointed to a serious factual error: Quirinius became governor of Syria in 6 AD, after the death of Herod. At this point he did call for a census, as noted by the historian Josephus. At the time of Jesus' birth, however, the Syrian legate was Sentius Saturninus.

Contemporary theologians are increasingly of the opinion that this apparent contradiction derives from a mistranslation of Luke's use of the Greek word *protos*, which can mean not only "first" but also "former" or "earlier". In the Septuagint (the Greek translation of the Old Testament), the word appears to take on all these meanings at various points. If we were to translate Luke's apparently contradictory phrase another way, therefore,

Inscription at Monumentum Ancyranum, an ancient temple wall in Ankara, Turkey, discovered in 1555, confirming the imperial census decreed by Caesar Augustus in 8 BC.

QVIBVS · ORBEM · TERRARVM

·SENATV·DEPOPOSCI·ET·ACCEP
·PRINCEPS·SENATVS·FVI·VSQVE
·XIMVS·AVGVR·QVINDECIMVIRVM
·S·FETIALIS·FVI·PATRICIORVM
TER·LEGI·ET·IN·CONSVLATV·SEXTO
ENSIMVM·FECI·QVO·LVSTRO·CIVIVM
·M·ITERVM·CONSVLARI·CVM·IMPERIO
ROMANORVM·CAPITA·QVADRAGIENS
IO·LVSTRVM·CONLEGA·TIB·CAESARE
IVIVM·ROMANORVM·CAPITVM
GIBVS·NOVIS·INLATIS·MVLTA
·MVLTARVM·RERVM·EXEMPLA
SVLES·ET·SACERDOTES·QVINTO
DOS·ALIQVOTIENS·SACERDOTVM
MVNICIPATIM·VNIVERSI·CIVES
·PPLICAVERVNT· NOMEN
CTVS·VT·ESSEM·MIHI·DATVM

REDI·TI·NERONE·P·QVINTILIO·CONSVLIBVS·ARAM·PACIS·AVG
CENSVIT·AD·CAMPVM·MARTIVM·IN·QVA·MAGISTRATVS·ET·S
SACRIFICIVM·FACERE·IVSSIT· IANVM·QVIRINVM·QVEM·C
PER·TOTVM·IMPERIVM·POPVLI·ROMANI·TERRA·MARIQVE·ESSET
CONDITA·VRBE·BIS·OMNINO·CLAVSVM·FVISSE·PRODATVR·MEMORI
FILIOS·MEOS·QVOS·IVVENES·MIHI·ERIPVIT·FORTVNA·GAIV
SENATVS·POPVLVSQVE·ROMANVS·ANNVM·QVINTVM·ET·D
MAGISTRATVM·INIRENT·POST·QVINQVENNIVM· ET·EX·EO·D
CONSILIIS·PVBLICIS·DECREVIT·SENATVS· EQVITES·AVTEM·RO
EORVM·PARMIS·ET·HASTIS·ARGENTEIS·DONATVM·APPELLAVE
NVMERAVI·EX·TESTAMENTO·PATRIS·MEI·ET·NOMINE·MEO
QVINTVM·DEDI·ITERVM·AVTEM·IN·CONSVLATV·DECIMO·E
VIRITIM·PERNVMERAVI·ET·CONSVL·VNDECIMVM·DVODECIM
EMENSVS·SVM·ET·TRIBVNICIA·POTESTATE·DVODECIMVM·
QVAE·MEA·CONGIARIA·PERVENERVNT·AD·HOMINVM·MILI
TRIBVNICIAE·POTESTATIS·DVODEVICENSIMVM·CONSVL·XII
SEXAGENOS·DENARIOS·VIRITIM·DEDI· ET·COLONIS·MILIT·V

Tomb of Aemilius Secundus of Tivoli, inscribed with the name of Quirinius, who was legate of Syria.

we would end up with: "This was the census taken before Quirinius became governor of Syria", which would be historically correct.

St. Luke's critics contend furthermore that the Romans could not have carried out a census in Judea under Herod's reign, since this region fell beyond his jurisdiction. In reality, however, from the moment Pompey the Great conquered Jerusalem in 64 BC, the Israelites became entirely subordinate to Rome. Herod was a puppet king, a vassal of Caesar, and couldn't even draw up his own will without the emperor's approval. His power was severely limited. We know that in 8 BC he had to swear allegiance to Caesar, and historians note that this pledge was linked irrevocably with the condition of carrying out a census.

Stone inscription, carved in Beirut by Venetian merchants, mentioning the governor Quirinius.

An inscription discovered in 1555 on the Monumentum Ancyranum, the wall of an ancient temple in Ankara, Turkey, reveals that Caesar Augustus ordered a census across the empire in 8 BC. (Many scholars think Christ was born around 7 BC.) Historical sources inform us that such a survey was carried out around this time in Egypt and in Italy.

Everything suggests that Augustus' census covered not only those territories belonging directly to the empire, but likewise those that were subservient to Rome. These sorts of surveys usually took a long time to complete, particularly in geographically vast states. The historian Daniel-Rops noted that the French overseas territories register commenced under Louis-Philippe I was delayed in several places, reaching completion in Guyana in 1835, on Martinique in 1837, and on Guadeloupe in 1838. It would hardly be surprising, therefore, if the census ordered by Augustus in 8 BC wasn't realized in Judea until slightly later. This finds some corroboration in the work of Clement of Alexandria (150–212), who in his writings about the birth of Jesus mentions the censuses (plural) that had taken place around that time.

St. Luke in his Gospel refers to the "first" census taken by Quirinius, suggesting that he knew of a second. Indeed, he refers to this second census in the Acts of the Apostles: "Judas the Galilean arose in the days of the census and drew away some of the people after him; he also perished, and all who followed him were scattered" (Acts 5:37). The Judas to whom Luke refers earned his moniker after inciting a rebellion in Galilee in 7 AD, in reaction to the second census under Quirinius. The reason for the uprising

Statue of the great Roman historian Tacitus, in front of the Parliament Building in Vienna, Austria.

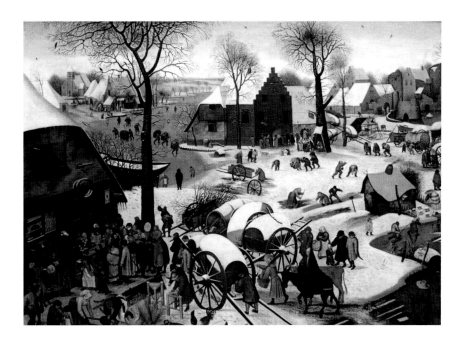

The Census at Bethlehem by Pieter Bruegel the Elder, dating from 1566, and currently held in the Museum of Fine Arts in Brussels, Belgium.

stemmed from the discord of having to swear allegiance to the Roman Emperor. The Jews regarded this act as blasphemy, a betrayal of their God.

We know that a population count of this type took place not just once in the Roman Empire, but every so often. The German author Werner Keller wrote: "The census is by no means the invention of modern statisticians. Practised in ancient times, it fulfilled then as now two extremely reasonable purposes: it provided the relevant information firstly for calling up men for military service and secondly for taxation purposes. In subject countries it was the second of these that mostly concerned the Romans. Without exacting tribute from its foreign possessions, Rome would never have been able on the strength of its own resources to afford the luxury of its much admired magnificent buildings and pleasances, its extravagant way of living, or its expensive system of administering its empire."

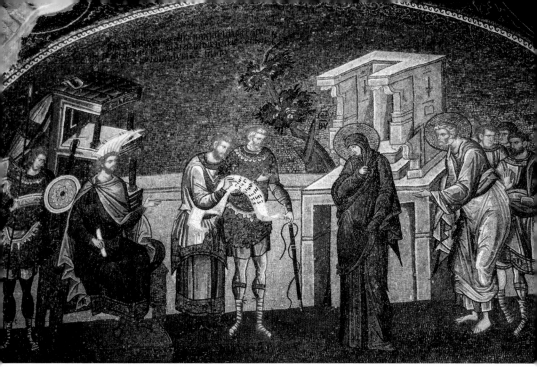

The census under Quirinius depicted on a mosaic in the Byzantine Church of the Holy Savior in Chora, Istanbul, Turkey.

Papyruses discovered in Oxyrhynchus, Egypt, in 1897–1898, reveal that censuses took place in this country, which borders Judea, every fourteen years. If we apply the same system to Palestine, we might surmise that since a census took place in 7 AD, the previous one might have been conducted fourteen years earlier, in 7 BC. It may also explain why the Pharisee rebellion occurred in Judea in that year, and why Herod subsequently ordered the murder of six thousand Jews. As already mentioned, a condition of every census was pledging allegiance to Caesar: a direct provocation to rebellion as far as the Jews were concerned. This was the case in 7 AD, and it was the case fourteen years earlier.

St. Luke's nineteenth-century critics accused the Evangelist of making up the census decree ordering individuals to register in their place of birth, as opposed to their current domicile.

Souvenirs of the Annunciation

IN CHRIST'S DAY, homes in the craggy regions of the Near East were often made of two portions. The first part was a grotto hollowed out of the rock, and the second a stone structure built around it. Christians have long believed that the Virgin Mary lived in just such a home in Nazareth. They venerate two places associated with the Annunciation, when the angel Gabriel asked her to be the mother of Jesus. The first is the hollowed grotto in Nazareth that is now found inside the Basilica of the Annunciation. The second is the stone chamber, once built around the grotto. When the Crusaders were driven out of the Holy Land in 1291, the sacred residence was taken apart, and the stones were eventually transported to Loreto, in Italy. Legend has it the stones were delivered by angels, which probably stems from the involvement of the Angeli family ("angels", in Italian). Three years later a shrine was built in Loreto, at the center of which was the Holy House built from the delivered stones (measuring about five feet high). Scientific tests discovered traces of mortar of a kind never used in the Appennine Peninsula, but common in ancient Palestine.

Grotto of the Annunciation in Bethlehem.

The Holy House of Loreto.

Yet archeological findings in the last century confirm Luke's version of events. A papyrus discovered in northern Africa contains the decree: "Gaius Vibius Maximus, Prefect of Egypt [says]: Seeing that the time has come for the house to house census, it is necessary to compel all those who for any cause whatsoever are residing out of their districts to return to their own homes, that they may … carry out the regular order of the census." In 1989, Israeli historians published the archived family records of a Jewish woman named Babata, which were discovered in a cave above the Nahal Hever canyon near the Dead Sea. Following analysis of these documents, a German scholar at Ben-Gurion University in Israel, Carsten Peter Thiede,

Jerusalem

ISRAEL

The Nahal Hever canyon, near to which ancient scrolls were discovered.

concluded that St. Luke "reproduced exactly the Roman registration procedure, together with its compulsory and onerous journeying, as well as its linguistic details." In the case of our Nazarene family, there may have been an additional motivation for setting out for Bethlehem. Mary discovered she was pregnant before she started officially living with Joseph. It is highly likely that an atmosphere of suspicion would have surrounded the couple. This socio-religious pressure may well have influenced Joseph's decision to leave Nazareth for a while and head for Bethlehem.

In the earlier part of the twentieth century, the Scottish archeologist, historian, and geographer William M. Ramsay (1851– 1939) of Aberdeen University, tried to prove that the New Testament contains numerous mistakes and factual errors. The object of his critical analysis was St. Luke, who in his writings mentions as many as thirty-two countries, fifty-four towns, nine islands, and the names of numerous rulers. Ramsay cross-referenced these with various historical sources and archeological findings and found not a single error. He even organized a trip to the Near East to research the New Testament's apparent fallacies. After fifteen years, however, the archeologist was compelled to write a book conceding that St. Luke was in fact a credible, reliable, and truthful historian.

We ought not to forget that during their missionary journeys, the Apostles were frequently met with skepticism, if not hostility. They related stories and events in which they had participated or to which they had been direct witnesses, and they made recourse to facts that their listeners would have known to be true. Any attempts at lying would have been exposed as falsehoods by a typically ill-disposed audience. The British Bible scholar Frederick Fyvie Bruce observed:

William M. Ramsay, Scottish archeologist, historian, and geographer, who set out to find errors in St. Luke's Gospel.

"It was not only friendly eyewitnesses that the early preachers had to reckon with; there were others less well disposed who were also conversant with the main facts of the ministry and death of Jesus. The disciples could not afford to risk inaccuracies (not to speak of willful manipulation of the facts), which would at once be exposed by those who would be only too glad to do so. On the contrary, one of the strong points in the original apostolic preaching is the confident appeal to the knowledge of the hearers; they not only said, 'We are witnesses of these things,' but also, 'As you yourselves also know' (Acts 2:22). Had there been any tendency to depart from the facts in any material respect, the possible presence of hostile witnesses in the audience would have served as a further corrective."

If the Evangelists had created fiction, then they would almost certainly have left out facts with which they were uncomfortable or which put them in a bad light. However, the American historian William Durant noted: "The evangelists ... recorded many incidents that mere inventors would have concealed: the competition of the apostles for high places in the Kingdom, their flight after Jesus' arrest, Peter's denial, the failure of Christ to work miracles in Galilee, the reference of some auditors to his possible insanity, his early uncertainty as to his mission ...; no one reading these scenes can doubt the reality of the figure behind them. That a few simple men should in one generation

American historian William Durant (top center of left photo), author of the monumental, eleven-volume *The Story of Civilization*.

Frederick Fyvie Bruce, one of the most influential Evangelical theologians of the twentieth century.

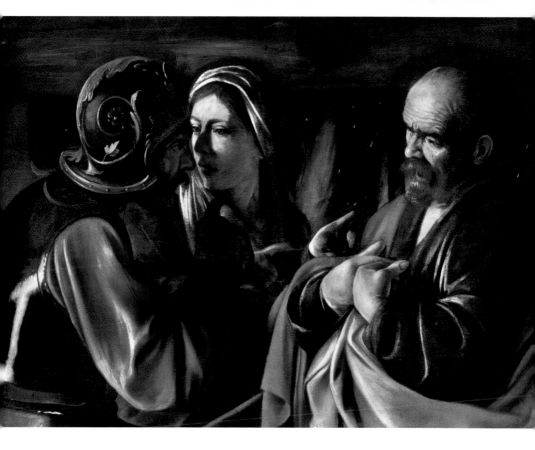

The Denial of St. Peter. Caravaggio's final painting, today kept in New York's Metropolitan Museum of Art.

have invented so powerful and appealing a personality, so lofty an ethic and so inspiring a vision of human brotherhood would be a miracle far more incredible than any recorded in the Gospels." Legends are distinct from commentaries in their neglect of facts. The accounts related by the Evangelists, however, are steeped in contemporary Israeli history. They abound with concrete geographical references, names of important figures, and customs or rules relating to everyday life. This is also true of St. Matthew's Gospel. Let us attempt, in that case, to scrutinize his factual account of the Magi from the East in the light of available scholarship.

35

Messianic prophecies

3

THIRD MYSTERY

MESSIANIC PROPHECIES

St. Matthew recounts that the Magi from the East came to Jerusalem asking where they might find the newborn king of the Jews. The Evangelist's account is not as far-fetched as it might initially seem. Around the start of the first century, the level of expectation concerning the Messiah's imminent arrival had reached its zenith. In his *Jewish Wars*, Josephus wrote it was this expectation that prompted the Israelites to revolt against the world's then largest military power.

The prophets of the Old Testament foretold the coming of the Messiah, who would bring about a new era in Israel's history.

Essenian manuscripts discovered in Qumran, near the Dead Sea, reveal that around the time of Christ's birth the Jewish sect was expecting the arrival of two messiahs. Messianic fever also took hold in popular contemporary Jewish literature, with examples including the Book of Enoch, the Testaments of the Twelve Patriarchs, the Fourth Book of Ezra, and the Apocalypse of Baruch.

It is surprising to note that the Jews weren't the only ones awaiting the arrival of someone extraordinary. In his *Histories*, Tacitus wrote that "in most there was a firm persuasion, that in the ancient records of their priests was contained a prediction of how at this very time the East was to grow powerful, and rulers, coming from Judaea, were to acquire universal empire."

This sense of expectation is evident likewise in the work of Virgil, who in his *Fourth Eclogue* (written a few decades before the birth of Christ) wrote about the coming of a "great age", thanks to a "new progeny, descending to earth from heaven". The poet described how a virgin would give birth to a boy, in whom the iron race would cease and the golden race arise. A similar observation was made by Suetonius in his *Life of Vespasian*: "A firm persuasion had long prevailed through all the East, that it was fated for the empire of the world, at that time, to devolve on some who should go forth from Judaea."

This sense of expectation among the Jews was founded on a number of biblical verses foretelling the Messiah's coming. Over centuries, his arrival had been heralded by Jewish prophets. Generations of sages and Scripture scholars contemplated these puzzling prophecies, trying to ascertain when this event might take place. Two verses from the Holy Scripture caused the Messianic obsession to reach its peak, around two thousand years ago. The first of these concerns Ja-

Suetonius

The Roman historian Suetonius, as depicted in Hartmann Schedel's *Nuremberg Chronicle* published in Germany in 1493.

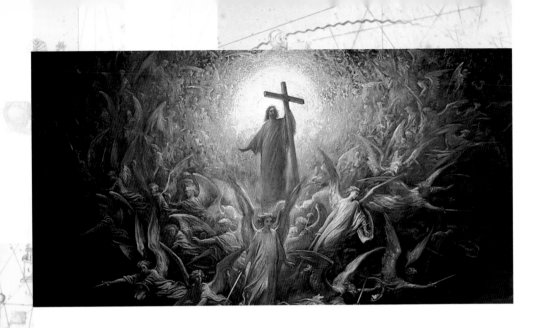

Jesus' life as fulfillment of prophecy

THE PREDICTION [concerning the Messiah], read in books of the Bible, finds definition and depth across almost three hundred very diverse messianic prophecies, which over several centuries detail a number of significant points concerning the coming, and show exactly what was supposed to happen. All these prophecies, without exception, find fulfillment in the life of Jesus. Only in him, and no one else. They describe with striking accuracy and with foresight of several centuries the details of Jesus' life. How can one predict such events? Above all, how is it possible that all these various prophecies were fulfilled in one and the same person?

Antonio Socci

Jesus' name in Hebrew carved into a tablet.

Fragment from the *Triumph of Christianity over Paganism* by nineteenth-century French painter Gustave Doré.

cob's prophecy regarding the "last days", which is the biblical term for the Messiah's coming: "The scepter shall not depart from Judah, nor the ruler's staff from between his feet, until he comes to whom it belongs; and to him shall be the obedience of the peoples" (Gen 49:10). This prophecy was fulfilled in Jesus' lifetime, if we consider that Palestinian authority was seized by the governors of Rome following the death of the last king of Israel, Herod the Great.

The second verse comes from the Book of Daniel, which is the most messianically oriented of all the Old Testament books. He foretells the coming of the messianic era and gives a precise date, namely 490 years after the Babylonian captivity. Depending on when one counts from, this would suggest a starting point sometime in the period from 48 BC to 33 AD. Daniel wrote that the Messiah "shall be cut off ... and the people of the prince who is to come shall destroy the city and the sanctuary" (Dan 9:26).

Roman legionnaires carrying loot, including the menorah from the Temple of Jerusalem, after quelling the Jewish rebellion. Fragment from the Arch of Titus in Rome.

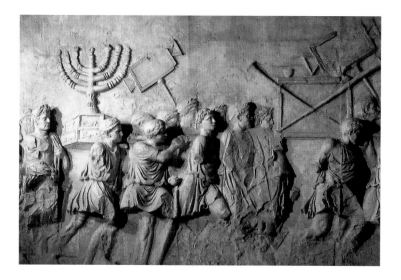

41

The prophet Baruch, author of one of the books of the Old Testament.

This also took place. In 70 AD, Jerusalem was conquered by Roman legions under Titus, and the Temple was destroyed. For those Jews who accepted Jesus as the Messiah, these prophecies were incredibly significant, giving credence to his mission. Conversely, those Jews who didn't follow Christ and remained faithful instead to the Law of Moses had to deal with the fact that this long wait had resulted in nothing. Rabbinic Judaism constructed a reoriented view of the idea of the Messiah, as Dante Lattes wrote in his *Apologia dell'ebraismo* (Apology for Judaism): "Jewish Messianism, initially conceived of in human form – a person in whom justice is affirmed and strengthened – turns into an idea: they think of the future, of the individual and collective aspiration of the people towards a true justice, and a religion made incarnate in History…. And so the Messiah-Man of heroic times, the ideal man of the future, the Son of David (the one who was awaited in the first age), becomes the Messiah-People. The 'Servant of God' is Israel, which suffers for the world's salvation, and its conversion."

For many Jews today, the Messiah-as-individual is roundly rejected in favor of a common savior, found in the nation of Israel. While this stance is not representative of Judaism as a whole, it obviously differs significantly from the dogmatic conception of the Messiah in a Catholic sense. In any case, the idea of an individual Messiah had always existed alongside the notion of a collective Messiah. The former was an animating force for scores of Jewish communities who over the centuries looked

to a number of false messiahs, such as Simon bar Kokhba in the second century, Sabbatai Zevi in the seventeenth century, and Jacob Frank in the eighteenth century.

Evidence clearly suggests that at the start of the first century, the Jews expected the Messiah to come in human form. Protestant apologist Josh McDowell has counted as many as 456 messianic prophecies in the Old Testament. Rabbi Chil Slostowski from Dubno, Poland, whose study of the Bible prompted a belief in Jesus as Messiah, has discovered over two hundred messianic

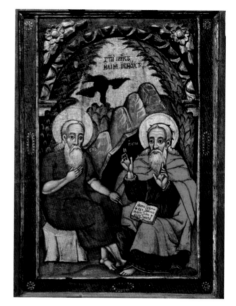

prophecies in the Old Testament that were fulfilled in Christ. In his *Jewish New Testament Commentary*, the Israeli theologian David H. Stern lists fifty-two Old Testament prophecies that are fulfilled in Jesus. American mathematician Peter Stoner has restricted himself to eight prophecies: (1) the Messiah's birthplace, (2) the foretelling of his coming by a messenger, (3) the means by which he arrived in Jerusalem, (4) his betrayal by

Elijah and Enoch were prophets who, according to the Bible, were raptured into heaven.

Evangelical apologist Josh McDowell.

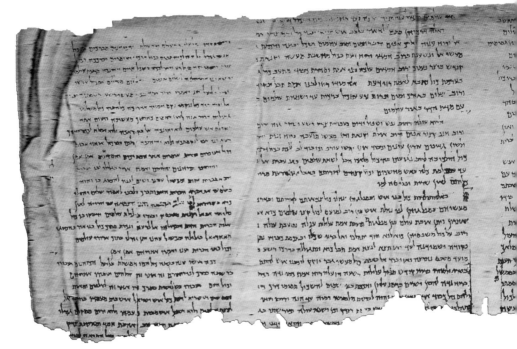

a friend, (5) his being sold out for thirty pieces of silver, (6) the abandonment of this money in the Temple, (7) his silence in the face of his accusers, (8) his death by crucifixion.

Stoner calculates that the likelihood of someone fulfilling these prophecies by chance at any point up to the present day is one in one hundred million billion. To put this in context, it would be like searching for a coin in a twenty-inch heap of similar coins, spanning an area about the size of Texas.

An individual fulfilling forty-eight prophecies is even more improbable. Stoner claims this would be like isolating a single electron from among all the electrons existing in the universe. And yet there was one individual in whom these prophecies found their culmination – Jesus Christ. He was the one the Magi were searching for.

All the messianic prophecies in the Old Testament were made across a period of several centuries. Together, they provide a consistent portrayal of an individual whose biography corresponds exactly with that of Jesus of Nazareth.

Addressing these unusual concurrences, the Canadian theologian Canon Dyson Hague wrote: "No one knew five hundred

Papyrus from Qumran, a scroll of Hebrew text predating Jesus' birth, discovered near the Dead Sea.

years in advance that Shakespeare would be born, or that Napoleon would be born two hundred fifty years earlier. And here, in the Bible, we have the most striking depiction of an individual, perfectly recognizable, which is the work of not one but twenty-five artists, none of whom ever even met the individual they sought to portray." In the words of French philosopher Jean Guitton: "No scholar, especially no philosopher, should feel comfortable while this issue remains unanswered."

In recent centuries, academics have attempted to tackle this particular problem. Beginning in the eighteenth century, when Enlightenment thought first made an impact on theology, several scholars started to dispute the veracity of the messianic prophecies. Since it seemed impossible to them that so many prophecies could find their fulfillment in Christ, they came up with another explanation. The Church was accused of committing fraud. It was adjudged that a proportion of the messianic prophecies were incorporated, post factum, within the Old

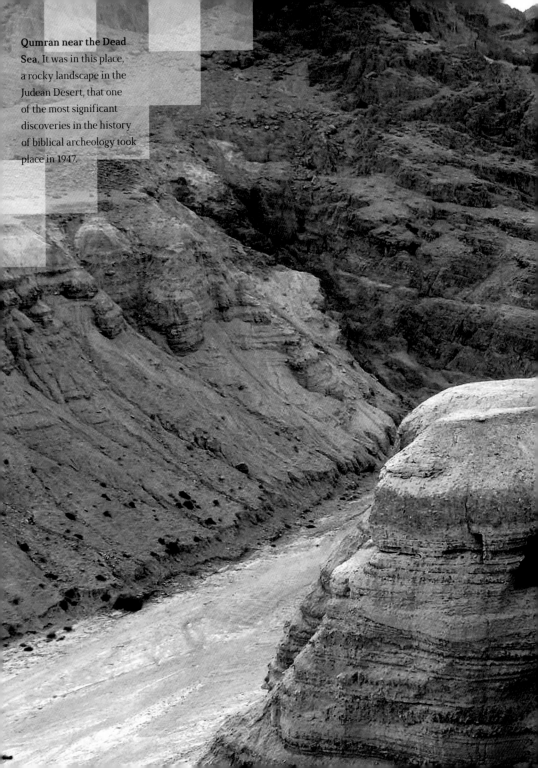

Qumran near the Dead Sea. It was in this place, a rocky landscape in the Judean Desert, that one of the most significant discoveries in the history of biblical archeology took place in 1947.

Remains of the ancient Essenian settlement at Qumran.

Testament by early Christians, in order to authenticate Jesus' mission.

However, the discovery of the Dead Sea Scrolls at Qumran in 1947 disproved this theory. The scrolls belonged to an ancient Jewish sect called the Essenes and dated from before the birth of Christ. They also comprised all the books of the Old Testament, with the exception of the Book of Esther. Significantly, they were shown to be no different from the corresponding texts used by the Church today, even containing the same messianic prophecies.

Modern-day critics have therefore looked for other ways of disputing the messianic proof of Jesus' mission. They have claimed that the prophecies did not foretell the coming of the Messiah, but referred instead to contemporaneous historical events. Christians were then supposed to have invested these biblical verses with prophetic meaning, distorting their original context.

This theory is contradicted by a large corpus of Jewish literature, dating from before the time of Christ (the Essenian library in Qumran, for instance), as well as

An Essene as depicted in Hartmann Schedel's *Nuremberg Chronicle.*

IN THE CHAOTIC ATMOSPHERE that characterized this epochal period, the poet Virgil foretold the birth of a child who would usher in a new era of Saturn. The Buddhists were preparing for the coming of Buddha Maitreya. The Hindus were speculating as to Vishnu's next incarnation. The Persians were dreaming of a savior named Saoshyant. And the Jews were awaiting God's Anointed One, the *moshiach*, which the Greeks translated as *Christos*, and which the Romans further modified into the Latin *Christus*.

Messianic fever sweeps the planet

Peter Seewald

For centuries, sun gods populated the mythology of Near Eastern peoples.

Papyrus from Qumran, referred to as 11QMelch.

after (rabbinic literature up to the tenth century). In the interwar period, the French-born Jewish writer Jean-Joseph Brierre-Narbonne decided to confront this issue. The result of his research was a five-volume work analyzing the messianic prophecies from the perspective of a variety of Jewish traditions, centered on the Talmud (the core text of Rabbinic Judaism), the Midrash (biblical exegesis from the post-Temple era), the Zohar (the foundational work of the Kabbalah tradition), the apocrypha (noncanonical writings), and the Targumim (portions of the Old Testament translated or paraphrased in Aramaic). It turned out that the biblical verses acknowledged by these Jewish traditions as messianic prophecies were the same as those to which Christians referred. When Brierre-Narbonne discovered that these prophecies found their fulfillment in Christ, he converted to Catholicism.

The archeological excavations at Qumran brought with them yet more revelations. Among the discovered texts were several messianic forecasts. Drawing on their own analysis of biblical prophecies, the Essenes calculated that the Messiah would be born in the period between 10 BC and 2 AD, which of course tallies with the date of Christ's birth. By examining the Qumran fragment known as 11QMelch, for instance, we can see that the Essenes formulated their forecast not on the basis of celestial observations, but on the exegesis of Holy Scripture.

Who was the Messiah? The word in Hebrew means "anointed", which in Greek is translated as *Christós*. Christ is there-

fore not merely a part of Jesus' name but a historical role or title. The Jews likened this "anointed Lord", foretold by prophets, with the figure of an ideal king destined to bring freedom to Israel, together with governance founded on law and justice. The most widespread view of messianism at that time therefore linked the long-awaited Son of David with the distinction of a monarch. Jesus of Nazareth incorporated his mission within this narrative, but utterly changed its meaning by declaring a new reality. As he said to Pontius Pilate: "My kingship is not of this world" (Jn 18:36). In this context it may seem reasonable that the Magi came from the East, asking – as St. Matthew wrote – after a newborn king.

Archeological excavations at Qumran near the Dead Sea.

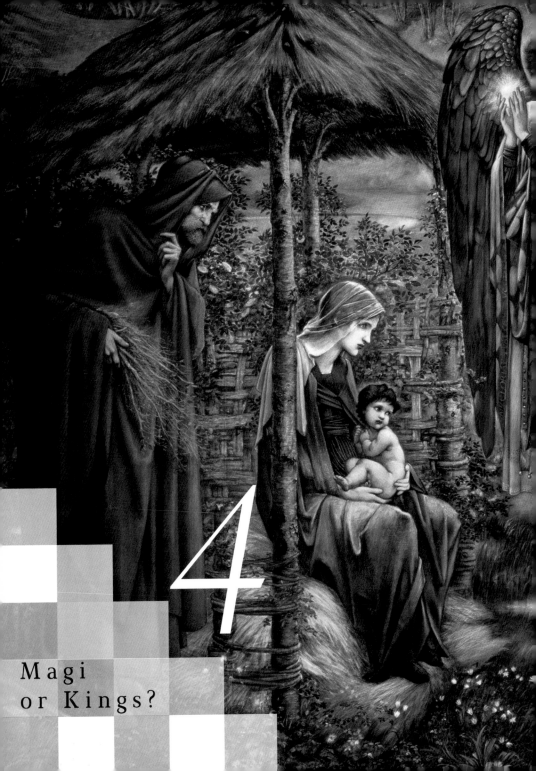

4

Magi
or Kings?

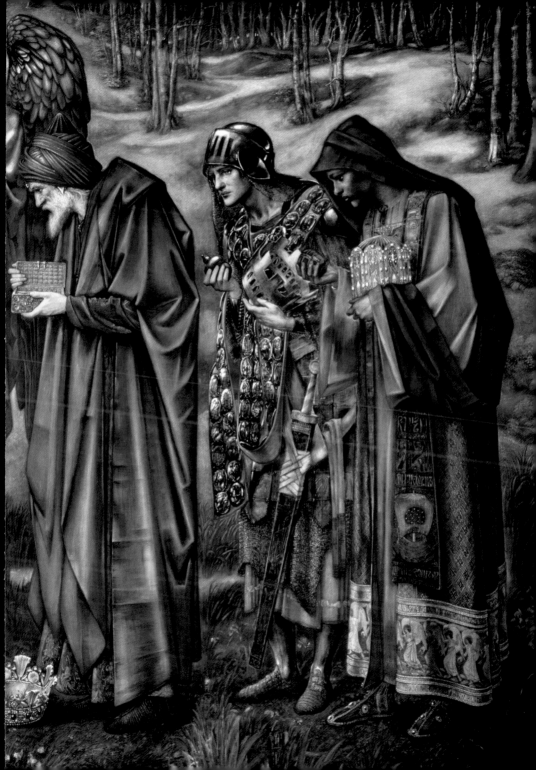

FOURTH MYSTERY

MAGI
OR KINGS?

Exactly who were these Three Kings, who trav-
eled from the East to Judea to worship before
the Christ Child? Were they really monarchs? St.
Matthew makes no reference to the fact that they
might have been rulers. He simply calls them the
"Wise Men from the East" – or, in Greek, *magoi
apo ton anatolon.*

The Adoration *of the Magi.* Relief on the bronze doors of the Cathedral of the
Assumption of Mary in Hildesheim, Germany.

The Greek word *magos* appears in the New Testament just five times. According to German theologian Gerhard Delling, the word had four different meanings in Hellenistic culture: first, it was the name for a member of the Persian sacerdotal caste, or the Magi; secondly, it referred to one who was learned in esoteric or occult practices; thirdly, it was the name for a sorcerer; and fourthly, more derogatorily, the term stood for a trickster, astrologer, or interpreter of dreams. In the Acts of the Apostles, the false prophet Elymas of Paphos is referred to as a magus, indicating that the word could be used in both a positive and a negative sense.

Since the Wise Men, or Magi, observed the star in the sky, we can assume that they were familiar with astrology. This is by no means unusual. Astral cults played a significant role in the lives of ancient religious communities. Individuals saw the sun, moon, stars, and planets as representations of a separate, heavenly, and mysterious world. According to the *Dictionary of Biblical Theology*, edited by Xavier Léon-Dufour: "The celestial bodies seemed for this person to be a manifestation of supernatural power, reigning over the people and deciding their fate. He gave spontaneous thanks to these celestial powers, in order to earn their favor. The stars prompted the belief that the world was

Persian scholars with astronomic apparatus, depicted on an old wood engraving.

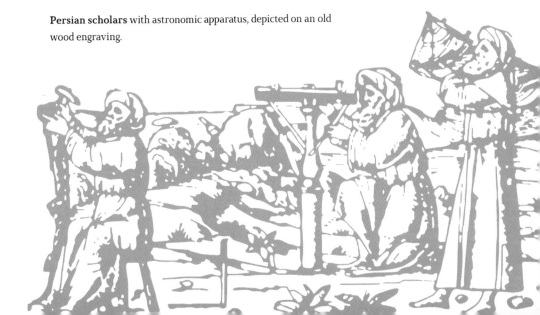

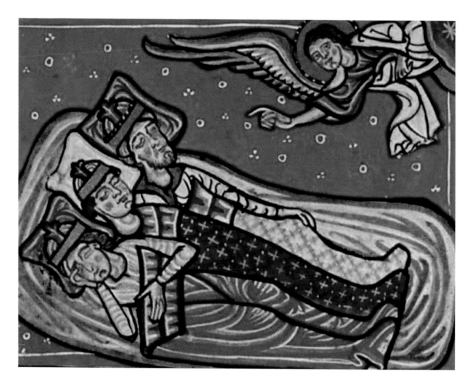

The Three Kings sleeping, and an angel telling them not to return to Herod, but to return home by another way.

governed by an eternal cycle, and that it was there, from above, that the stars marked out a certain holy rhythm for the benefit of earthly things below."

In the ancient world there was one race that openly mistrusted astrological practices, deeming them idolatrous. The Israelites had received a command from God to avoid soothsayers, summoners of spirits, and astrologers. Only God could give signs, through the words of his prophets. As the prophet Daniel said to King Nebuchadnezzar: "No wise men, enchanters, magicians, or astrologers can show to the king the mystery which the king has asked, but there is a God in heaven who reveals mysteries" (Dan 2:27).

In this context, it is perhaps not surprising that the arrival of the Magi in Judea, along with the message that they followed a

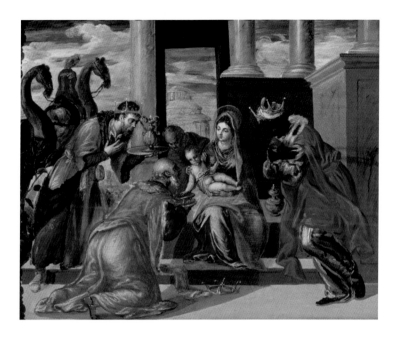

The Adoration of the Magi, painted by El Greco, 1575, private collection.

star heralding the birth of the Messiah, caused some shock in Jerusalem. While the prophets had foretold the Messiah's coming about this time, no one from among the Jews had taken to observing the sky for any sort of sign.

Another skill attributed to magi was the ability to interpret dreams. In many countries, this skill was the preserve of the priesthood. Some even learned how to guarantee pleasant dreams. In Egypt, papyrus "dream books" were produced, offering interpretations of various subconscious desires experienced during sleep. In Rome there was even an obligation to discuss one's dreams in public when they concerned some aspect of the state or empire.

Dreams were, therefore, certainly not regarded as something insignificant or trivial by inhabitants of the ancient Eastern world. They crop up quite often in the Bible, usually as a means of transmitting messages from God. Not everyone was endowed with the gift of interpreting these symbolic messages. Those who

had this gift were held in great esteem by Jews and Gentiles. We may point to Joseph and his elevation in Pharaoh's court in Egypt, as related in the Book of Genesis, as an example. Joseph's interpretations (such as the one concerning the seven fat cows and the seven lean cows dreamt by Pharaoh) are proof of how dreams and their meanings could occasionally alter the political life of an entire nation.

In his Gospel account of Jesus' birth, St. Matthew mentions the dreams of St. Joseph and the Magi. Their experiences seem to differ. Twice an angel of the Lord appeared before Joseph in his dream and referred to him by name. The first time, the angel told Joseph to take Mary, who was pregnant, into his home. The second time, he told Joseph to flee with his family to Egypt. In the case of the Magi, St. Matthew did not mention the appearance of an angel. He wrote only that they were "warned by God in a dream" (Mt 2:12). We do not know whether this was a direct command, or if the dream required interpreting. Certainly the Wise Men were convinced by the message, since they heeded the warning and did not return to Jerusalem.

How many individuals had the same dream that night? A couple? Several? A few dozen? Matthew's Gospel does not provide a

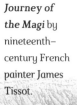

Journey of the Magi by nineteenth-century French painter James Tissot.

Magi, or truth seekers

THE MEN OF WHOM MATTHEW SPEAKS were not just astronomers. They were "wise". They represent the inner dynamic of religion toward self-transcendence, which involves a search for truth, a search for the true God and hence "philosophy" in the original sense of the word.

Pope Benedict XVI

FROM A HISTORICAL PERSPECTIVE, the Magi's journey to Bethlehem is not impossible. These were individuals open to the idea of monotheism. But since this episode is filled with uncertainties – number, significance, names – Christian devoutness and imagination filled in the blanks.

Fr. Waldemar Chrostowski

The Adoration
of the Three Kings in a
German illuminated Bible.

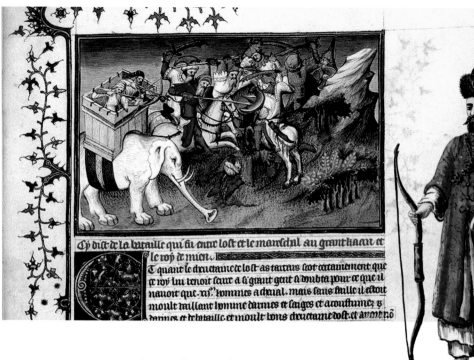

specific number. In the early centuries of Christianity, particularly among the Syrians and Armenians, it was surmised that there may have been twelve Magi – a reference to the twelve tribes of Israel. The symbolic implication was that God's divine favor would pass from the Jews to a Church composed of both Jews and Gentiles. Second- and third-century frescos in the Roman catacombs variously depict two, four, or six Magi. To this day, the Coptic Church in Egypt holds that as many as sixty Wise Men came to Judea – a veritable entourage.

In the Western world, the most popular number finds its beginnings in the writings of one of the Church Fathers, Origen: "There were three magi, since three gifts were offered: gold, frankincense, and myrrh." This is the number of figures depicted in the famous sixth-century mosaic found in the New Basilica of St. Apollinaris in Ravenna, Italy.

We don't actually know what the Magi were called. The traditional names of Caspar, Melchior, and Balthasar have their origins in the sixth century. Each name is derived from a word

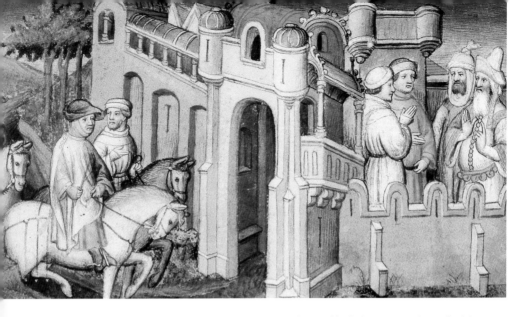

Illustrations from Marco Polo's *The Description of the World*, which mentions the tomb of the Three Magi in the Persian town of Saveh. Previous page: the author in Tatar dress.

meaning "king": Caspar derives from the Latin *caesar*, and shares an etymological root with the German *kaiser*; Melchior is derived from the Hebrew *melech*; while Balthasar stems from the Greek *basileus*.

These kingly appellations appeared in large part due to Christian teaching, which in the sixth century began to reconstruct the Magi as monarchs. It is quite likely that this occurred as a result of theological interpretations of Psalm 72, which contains the following messianic prophecy: "May the kings of Tarshish and of the isles render him tribute; may the kings of Sheba and Seba bring gifts! May all kings fall down before him, all nations serve him" (10–11). The idea that the Wise Men from the East were kings has its basis in this text. In addition, they symbolized the extent of the known world: Tarshish was likely a Phoenician colony that some scholars place in southern Spain. Sheba is thought to have spanned modern-day Ethiopia and Yemen.

In time, Christian imagination began adding other biographical details. Melchior was said to be about sixty years old, Balthasar about forty, and Caspar about twenty. In this way, they could be

61

seen to represent all generations, from old to young. This is also the way they are frequently depicted in medieval paintings.

Later, the kings' respective ancestries were detailed by drawing on the Book of Genesis, in which mankind is shown to have descended from Noah's sons: Shem, Ham, and Japheth. Shem's descendants – the Semitic peoples – settled in Asia; Japheth's progeny proliferated in Europe; Ham's lineage was to be found in Africa. The Wise Men were therefore shown to have their origins in each of the three corners of the ancient world. One was depicted with an Arabic complexion, another was made to look Greek, while the third king was black.

We do not know what happened to the Kings after they had paid their respects to the Christ Child. Matthew wrote only that they returned to their own country. In time, however, stories began circulating that they were baptized by one of the Apostles, went on to become bishops, and eventually became martyrs. In his *Description of the World*, the thirteenth-century Venetian traveler Marco Polo wrote: "In Persia is the city of Saba, from which the Three Magi set out when they went to pay homage to Jesus Christ.... In this city they are buried, in three very large and beautiful monuments.... The bodies are still entire, with hair and beard remaining." The French missionary Bl. Odoric of Pordenone made the same observation in 1320.

Today the Three Magi are venerated in the Catholic Church as the patron saints of travelers, pilgrims, merchants, innkeepers, and furriers. Pope Benedict XVI assessed their significance thus: "We could well say that they represent the religions moving toward Christ, as well as the self-transcendence of science toward him. In a way they are the successors of Abraham, who set off on a journey in response to God's call. In another way they are the successors of Socrates and his habit of questioning above and beyond conventional religion toward the higher truth. In this sense, these figures are forerunners, preparers of the way, seekers after truth, such as we find in every age."

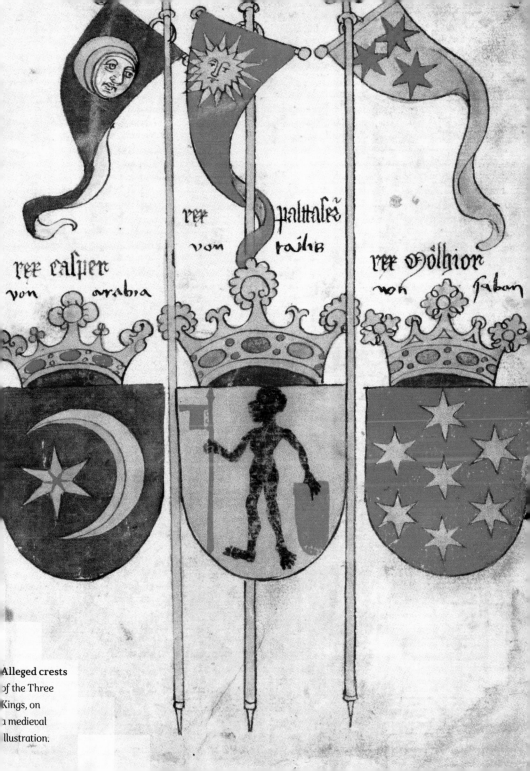

rex **ealper** von arabia

rex **palttaser** von tarsis

rex **Oolhior** von saban

Alleged crests of the Three Kings, on a medieval illustration.

The Magi's homeland

5

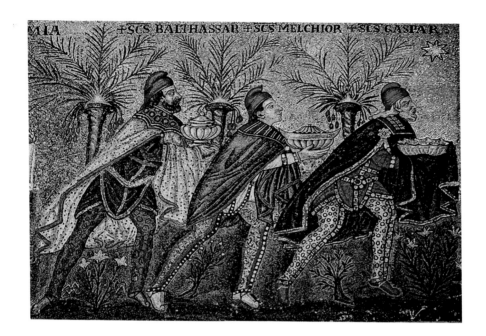

+SCS BALTHASSAR +SCS MELCHIOR +SCS GASPAR

FIFTH MYSTERY

THE MAGI'S HOMELAND

Where did the Magi come from? St. Matthew's Gospel reveals that they came "from the East", or *apo ton Anatolon* in the Greek. For the Greeks, the East would have signified Anatolia, or Asia Minor – where the sun rose. For the Israelites on the other hand, the East would have denoted countries like Mesopotamia, Arabia, or Persia. The oldest Christian traditions maintain that the mysterious travelers were indeed Persian.

The Three Magi in Persian priestly dress, as seen in a sixth-century mosaic in the New Basilica of St. Apollinaris in Ravenna, Italy.

66

This is the view held by a contemporary theologian and cowinner of the Ratzinger Prize, Monsignor Waldemar Chrostowski. The Persians – as distinct from Arabs or Jews, who are Semitic peoples – are Indo-European (similar to the Slavic, Germanic, and Anglo-Saxon peoples). Archeologists estimate that they arrived in modern-day Iran some fifteen centuries before the birth of Christ. It is worth looking briefly at their later migratory history and, in particular, at how they established a connection with the Israelites.

In 559 BC, Cyrus the Great rose to the Persian throne, gaining renown as a politician and a military general. He defeated the Median overlords, conquered the Parthians and Lydians, and took over Anatolia, Armenia, and Cappadocia, before challenging the mighty Babylonian Empire. This last war ended in 538 BC, with the fall of Babylon. Here, Cyrus encountered the Jewish people, who for half a century had endured the Babylonian captivity. They had been enslaved by Nebuchadnezzar II in 586 BC, following his occupation of Jerusalem and destruction of the Temple.

In contrast to the Babylonian king, Cyrus went down in Jewish history as their benefactor – he allowed the Jews to return to the Holy Land, and even to rebuild their Temple. The Persian ruler, who conquered the vast majority of the Near Eastern lands (with

The scene
of the Adoration
of the Magi, on
a fourth-century
sarcophagus from
the St. Agnes
Catacomb in
Rome.

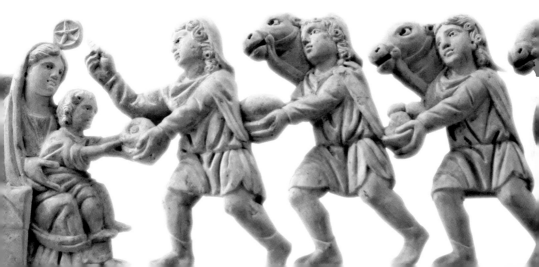

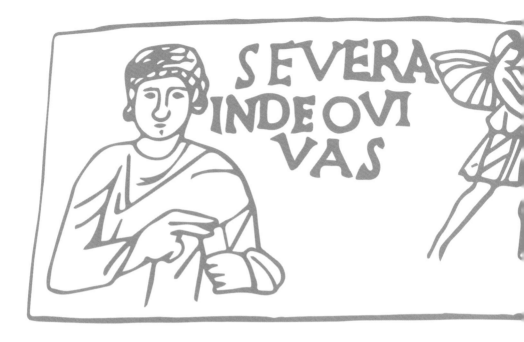

Roman epitaph of a woman named Severa (turn of the fifth century), with a scene from the Adoration of the Magi from the East.

the exception of Egypt), also retained frequent contact with Jews who traced their lineage back to an earlier deportation, namely the Assyrian captivity. This period of exile began in 722 BC, with fifty thousand Israelites being forced into Mesopotamia. Despite living in captivity, the Jews managed to retain their religious identity, and even preserve it by transcribing books of the Old Testament. They also played an important role in the Persian state, as evidenced in the Book of Esther and the Book of Tobit.

Not all the Israelites took advantage of Cyrus' offer to return to the Holy Land. A proportion of them remained voluntarily in exile, accumulating wealth and occupying certain social positions. Over the following centuries, a Jewish presence would therefore remain in Persia and Mesopotamia, creating a significant diaspora still true to its religious roots. This expatriate community would eventually become prosperous enough to influence the shape of

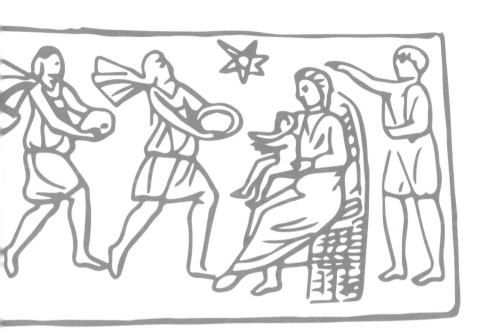

the entire Jewish faith. Within these territories rabbis produced the Talmud, which to this day remains the core text of Rabbinic Judaism. Because of this, as Fr. Chrostowski explains: "For several centuries the Persians were able to encounter the Jewish religion. They had the chance to get to know the religion of biblical Israel. They had thousands of Israelites living in their country. We might compare this to the situation during the First and Second Polish Republics, during which time [Poland] was home to millions of Jews. And even if there was a separation between Poles and Jews, Ukrainians and Jews, Belorussians and Jews, their coexistence necessarily meant that both sides, both communities, knew each other. Every local Catholic had some comprehension of what Judaism entailed. And conversely, every Jew had an idea of what Christianity stood for, since both groups came into contact with each other on a day to day basis."

Thanks to the generations of Israelites who lived in Persia and Mesopotamia, Judaism was known about and explored by people outside the Jewish diaspora, by magi, pagan priests, and proselytes from paganism. Judaism spurred an interest especially among the

69

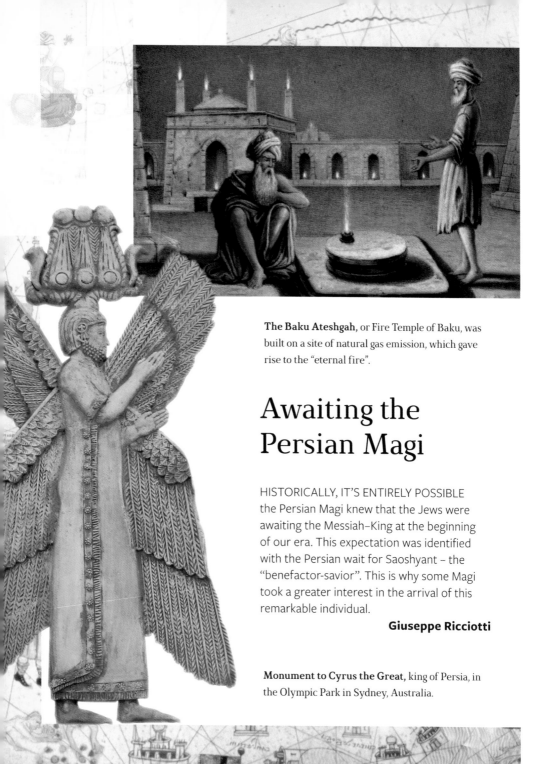

The Baku Ateshgah, or Fire Temple of Baku, was built on a site of natural gas emission, which gave rise to the "eternal fire".

Awaiting the Persian Magi

HISTORICALLY, IT'S ENTIRELY POSSIBLE the Persian Magi knew that the Jews were awaiting the Messiah–King at the beginning of our era. This expectation was identified with the Persian wait for Saoshyant – the "benefactor-savior". This is why some Magi took a greater interest in the arrival of this remarkable individual.

Giuseppe Ricciotti

Monument to Cyrus the Great, king of Persia, in the Olympic Park in Sydney, Australia.

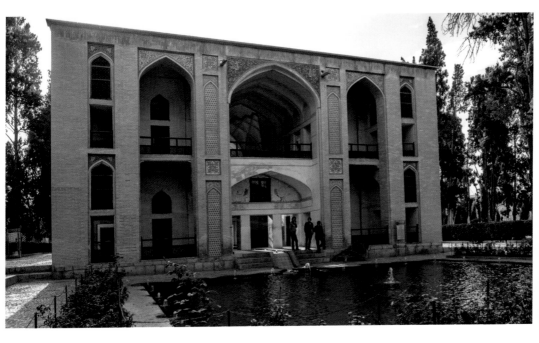

The Fin Garden in Kashan, a city in Persia (modern-day Iran) from which the Three Kings are believed to have set out on their journey.

Persians, who for the most part were followers of Zoroastrianism. This was a dualistic faith, which claimed that the fate of the world was determined by the opposition of two essential forces: Good, represented by Ohrmazd, meaning "illuminating wisdom", and Evil, represented by Ahriman, or the "destructive sprit". Some Zoroastrians found themselves drawn to Judaism. According to the Greek philosophers Xanthus, Hermodorus, and Aristotle, magi were known as followers of Zoroaster, or Zoroastrian priests.

The Italian historian Giulio Firpo made an interesting observation in this context, relating to "a tradition stemming from Zarathustra, according to which 'the prince of virtue will triumph over evil thanks to the benefactor, truth incarnate, who is to be born of a virgin, to whom no man will come close.'" This "benefactor" (the literal meaning of the name Saoshyant, a figure of Zoroastrian eschatology), who is also "truth" or "righteousness incarnate" (Astvat-ereta), is charged with resurrecting the dead and delivering justice to mankind – making him a very similar savior-figure

71

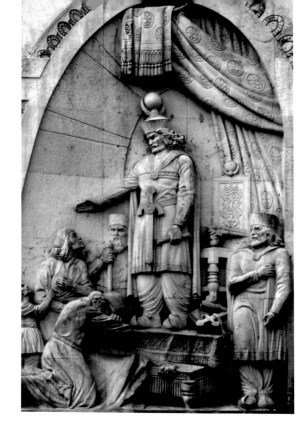

Relief of the Persian king Chosroes I, "the Just", of the Sassanid dynasty, on a wall of the Justice Palace in Tehran, Iran.

to the Jewish Messiah. On the basis of this evidence, Italian historian Franco Cardini has asserted that St. Matthew must have written the truth, as there is no way a simple taxman from Galilee could have incorporated Zoroastrian beliefs so exactly within his Nativity account.

The Babylonian and Persian territories were also renowned for their astrological schools, where earthly events were foretold by reading the stars. The hypothesis therefore proposed by Fr. Chrostowski claims that the Wise Men from the East were Persian magi, who were learned in astrology and who were familiar with Judaism, including its messianic prophecies. Some of these prophecies were clearly linked with astronomic phenomena, such as the following from the Book of Numbers: "A star shall come forth out of Jacob, and a scepter shall rise out of Israel" (24:17).

The Magi must also have registered the universal implications of the messianic prophecies. He was foretold as a savior not just of the Jews, but of the whole world. In the Book of Isaiah we read: "Nations shall walk by your light; and kings in the brightness of your rising" (60:3), while in Psalm 72 we find the following: "May the kings of Tarshish and of the isles render him tribute, may the kings of Sheba and Seba bring gifts! May all kings fall down before him" (10–11).

According to Fr. Chrostowski, numerous Persian groups would have known about these prophecies, because of their close contact with the Israelites. Some of them, the most zealous, likely looked forward to the Messiah's coming, together with and as intensely as the Jews. The Magi numbered among them.

In the famous sixth-century mosaic found in the New Basilica of St. Apollinaris in Ravenna, Italy, the Magi are presented in the traditional dress of Persian priests, wearing characteristic Phrygian caps, such as those that were excavated in Persepolis (see page 66). They are depicted in similar fashion in a painting in the Church of the Nativity, in Bethlehem. The current edifice was built by the Emperor Justinian in 565 to replace an older building destroyed by fire. When the Persian armies under Chosroes II invaded Palestine in 614, they destroyed a number of basilicas, including the Church of the Holy Sepulcher in Jerusalem. However, the Church of the Nativity was spared when the invaders saw the familiar depictions of the Magi in Persian robes. Witnessing how their compatriots were venerated in this place, they decided to leave the basilica in peace.

Persian ruler
Chosroes II, who conquered Jerusalem in 614 AD.

73

6

SIXTH MYSTERY

JESUS' BIRTH DATE

Was Jesus really born on the day traditionally regarded as his birthday, namely December 25? Was he even born in the year 1 AD?

Pope John I decreed the institution of a new chronological measure of time, whose start was the birth of Christ.

Up until the sixth century, historical time in West-
ern civilization was measured from the founding of Rome – the
imperial capital and later the Holy See. However, when the Visi-
goths conquered the Eternal City for the first time in 410, Chris-
tian theologians decided to separate the civilized and Christian
conceptions of time. After the sack of Rome, St. Augustine of
Hippo was moved to write his *City of God*, in which he clearly
stated that the fall of the Roman Empire did not signify the fall
of the Roman Church.

In time, as the empire bowed under pressure from the bar-
barians, there arose the need for a new calendar. It was argued
that historical time could be measured only from a point that
was permanent, immutable. Until then, it was believed that the
proud and indomitable Roman Empire represented that perma-
nence. But it would go the way of other superpowers, whose glo-
ry eventually faded, which was why a new measure of time was
proposed by Pope John I, who was pontiff from 523 to 526. The
start of a new system of chronology would be marked not by the
founding of a city, but by the birth of Jesus Christ – true God and
true man, the absolute foundation of human existence.

The pope charged an Armenian monk by the name of Dio-
nysius Exiguus, originally from Scythia Minor
(in the Danube delta, the modern-day
Romanian-Ukrainian border region)
with the responsibility of coming up
with this new calendar system. Diony-
sius calculated that Jesus must have
been born 753 years after the found-
ing of the city of Rome. Pope John
I accepted the monk's reasoning as
the basis for the new Christian cal-
endar, which gained universal ac-
ceptance.

Sun dial excavated in the Holy Land.

However, Dionysius made a few errors in his calculations. First, he overlooked four years of Caesar Augustus' reign, during which he governed under his patronymic Octavian. Secondly, he omitted the year zero, which ought to have been factored in between 1 BC and 1 AD. Thirdly, he did not take into account the fact that the Roman year numbered 365 days, while the Jewish year – based on the length of lunar months – numbered 364. As a result, the beginning of the new era according to Dionysius didn't actually tally with historical events. These days, most scholars believe Christ was actually born around 7 BC. If not for Dionysius' error, we would have celebrated the recent millennium back in 1993.

The New Testament makes no mention of Christ's birth date. Could it have been December 25? The French theologian Jacques Duquesne has written: "Jesus could not have been born in December. Even in Palestine it's too cold then for shepherds and their flocks to spend the night outdoors." Yet in St. Luke's Gospel we read: "And in that region there were shepherds out in the fields, keeping watch over their flock by night" (2:8).

Luke doesn't say the shepherds spent the night exposed in the open field. They may well have kept watch in shacks or tents, which were often used during colder months in the region. Some Bible scholars actually argue that the shepherds, in their long tunics and sheepskin coats, could well have spent the night under the stars. Another important factor gives credence to the December birthday. In 1989, near the Dead Sea, Israeli archeologists discovered the family records of a Jewish woman named Babata, which reveal that a census was conducted in December. This particular month, historians claim, was the most suitable for organizing a census among rural communities. It took place after the harvest, but before the sowing season, and therefore in a period of comparative rest.

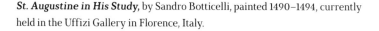

St. Augustine in His Study, by Sandro Botticelli, painted 1490–1494, currently held in the Uffizi Gallery in Florence, Italy.

Jesus' birth date

The date of December 25 is therefore a possibility, but by no means a certainty. The first mention of this date in the context of Christ's birth can be traced to the first half of the fourth century, when Christian persecution in the Roman Empire ceased following the Edict of Milan. We know the date was settled on somewhat arbitrarily – not on the basis of historical fact, but as a matter of convention. Since no one in the Church knew the actual date of Christ's birth, one had to be proposed.

But why December 25? Some scholars believe it had to do with the inculturation of the Christian message within Roman society. The twenty-fifth marked the winter solstice, which pagan cults used to celebrate the birth of their most important god, known by the Greeks as Zeus, and by the Romans as Jupiter. It was also celebrated as the *dies natalis Solis Invicti* (literally, "the birth day of the Unconquered Sun"), when followers of the Mithraic mysteries commemorated the birth of their god, Mithras. The Church therefore chose this particular date to emphasize Christ's importance over the pagan idols: his arrival effectively dethroned all other gods and marked the beginning of a new era.

Not all commentators share this view, however. Before he became pope, Cardinal Joseph Ratzinger wrote: "The claim used to be made that December 25 developed in opposition to the Mithras myth, or as a Christian response to the cult of the unconquered sun promoted by Roman emperors in the third century in their efforts to establish a new imperi-

Statue of Mithras, sun deity, whose mysterious cult became widespread in the Roman Empire during the first century.

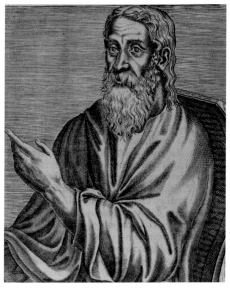

al religion. However, these old theories can no longer be sustained. The decisive factor was the connection of creation and Cross, of creation and Christ's conception. In the light of the 'hour of Jesus', these dates brought the cosmos into the picture. The cosmos was now thought of as the pre-annunciation of Christ."

Over the centuries, a number of hypotheses have been put forward concerning Christ's birth date. St. Clement of Alexandria suggested it was April 19. May 29, July 7, and November 17 have also been proposed as alternative Christmases. It has been suggested that the alignment of Jupiter

Astronomical clock made by Hans Düringer in 1463–1470, kept in the Basilica of the Assumption of the Blessed Virgin Mary in Gdańsk, Poland.

"You know neither the day nor the hour."
—Mt 25:13

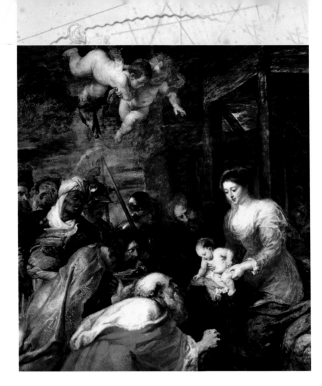

FOR US CHRISTIANS, the passing of millennia makes it difficult to accept the fact that the time Christ, God and Man, saw the light of day, is increasingly lost to history. In this mystery there is a beautiful and profound meaning, however. The One who is Lord of time and who existed in time, deemed it proper to place man, the epitome of created beings, in a situation where man, today renowned for the power of his intellect, was unable to give a birth date to his Creator. Does this problem merely arise from a lack of sources? Or perhaps it's a lesson in humility.

Fr. Tadeusz Kasabuła

The Adoration of the Magi by Peter Paul Rubens, now in the chapel of King's College, Cambridge.

and Saturn heralded Christ's birth – making May 29, October 1, and December 5 possibilities. Basing their assertions on the belief that numerous events in Christ's life corresponded with Old Testament feasts, Protestant exegetists have suggested September or October as potential birth dates, thus coinciding with the Feast of Tabernacles: a feast whose symbolism was to a great degree concerned with the Messiah's arrival.

In Eastern Churches, who continue to celebrate the liturgy in accordance with the Julian calendar, Christmas is celebrated on January 7. In the West, where the Gregorian calendar is employed, it falls on December 25.

The French Bible scholar Charles Perrot had it right, therefore, when he declared the case was "still open". The date of Christ's birth remains shrouded in mystery.

Emperor Constantine the Great before Pope Sylvester I. Fresco in the Roman Church of the Four Crowned Martyrs.

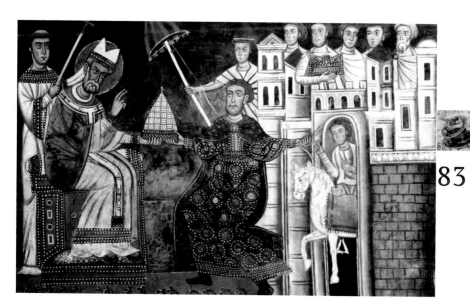

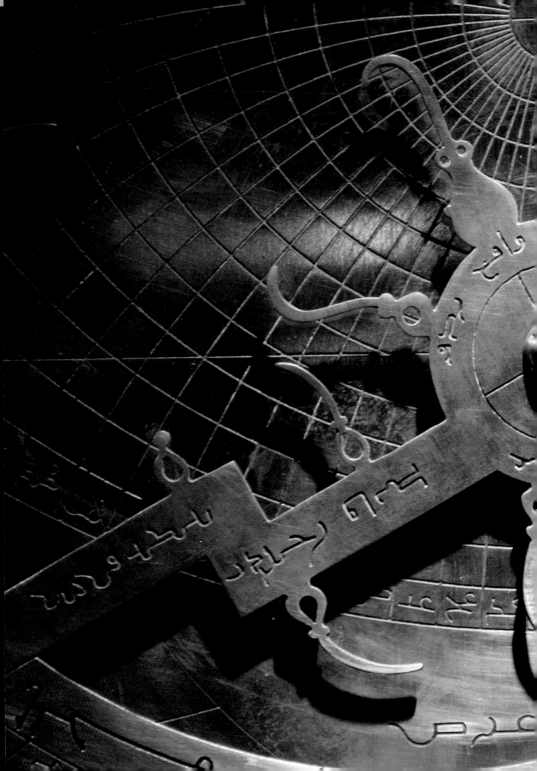

7

Signs in the sky

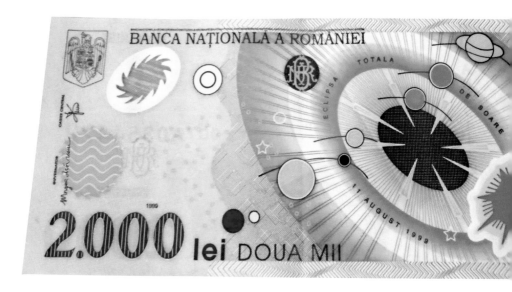

SEVENTH MYSTERY

SIGNS IN THE SKY

The Magi who came to Bethlehem claimed they had been led there by a star. Could that really have been the case? Was that enough to make them set out on such an arduous and lengthy journey?

History, it seems, can provide numerous examples of similar astronomically inspired pilgrimages, even in modern times. When the last total solar eclipse of the twentieth century took place on August 11, 1999, tourists from all over the world traveled to Romania to observe the phenomenon. The National Bank of Romania issued a new 2,000 lei banknote commemorating the event. A special polarizing filter was

incorporated as part of the paper note's design, allowing observers of the eclipse to look safely at the sun.

For people living in ancient times, astronomic phenomena were even more important than they are today, as they were interpreted not just in terms of physics, but in a metaphysical context. Often the stars were consulted in an attempt to understand what was happening, or going to happen, in human affairs. There is nothing especially unusual, therefore, about the journeying Magi.

One question does remain, however: What exactly did they see in the sky that prompted them to embark on their journey? In Nativity scenes today, the Star of Bethlehem is often shown as a comet, with a tail. This sort of representation only made its way into Christian iconography in the fourteenth century, however, in Giotto's *Adoration of the Magi* (see page 6). The Florentine artist was most likely influenced by an appearance of Halley's Comet in 1301, which is visible from Earth every seventy-five years or so. Astronomers have calculated that the comet would likewise have been visible in 12 BC, in which case it could not have been the star guiding the Magi.

On December 17, 1603, the German astronomer and mathematician Johannes Kepler observed an unusually intense light in the sky from his observatory in Prague, prompting his own investigation into the Star

Romanian 2,000 lei banknote with an illustration showing the total solar eclipse of 1999.

87

The Three Magi of the East are presented in royal robes and crowns in medieval depictions.

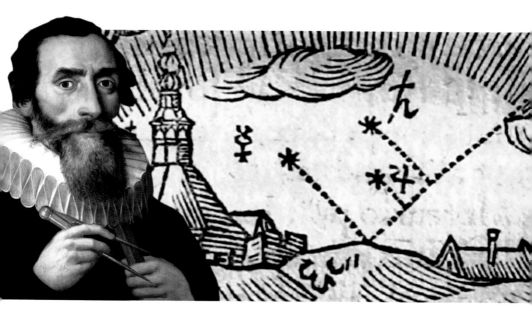

Johannes Kepler's illustration of the conjunction of Jupiter and Saturn in the constellation Pisces.

of Bethlehem. It was a conjunction of the planets Jupiter and Saturn in the Pisces constellation. A planetary conjunction is when two astronomical objects appear to align: an apparent coming together caused by perspective. In this instance, the two largest planets in the solar system aligned to create the effect of one very bright large star, which quickly faded.

Kepler calculated that this phenomenon occurred three times in 7 BC, in June, August, and December. Astronomers call three conjunctions within a period of time as short as this a "triple conjunction". Triple conjunctions take place in the same constellation, or the same part of the sky, only every eight hundred years.

Kepler also discovered a biblical commentary by Rabbi Isaac Abarbanel (1437–1508), in which the scholar and philosopher wrote about old Jewish beliefs that the Messiah would come when Jupiter and Saturn met in the Pisces constellation. Consequently, Kepler made his discovery public, claiming he had identified the Star of Bethlehem, and in 1606 he published a

treatise in Prague entitled *De Jesu Christi Salvatoris nostri vero anno natalitio.*

The scientific community received Kepler's discovery with great skepticism, however. In those days, Dionysius Exiguus' error regarding Christ's birth date had not yet been recognized. Indeed, everyone believed Jesus had arrived seven years later than was really the case. No wonder, therefore, that Kepler's findings were considered unreliable. Opinion changed only in the twentieth century, following the discovery and publication of an ancient Egyptian planetary epoch table in 1902. The table showed astronomic calculations based on observations made by the Egyptians between 17 BC and 10 AD. As it turns out, in 7 BC they observed and recorded an unusually bright light appearing in the sky, as a result of the conjunction of Jupiter and Saturn.

Astronomic sketch produced by Johannes Kepler.

The verification of these findings brought a further discovery. In 1925, the German orientalist Paul Schnabel successfully deciphered Neo-Babylonian inscriptions on an astronomy calendar found at the renowned School of Astrology in Sippar, on the Euphrates. The cuneiform script found on a little terracotta tablet recorded – with a great degree of precision – a triple conjunction of Jupiter and Saturn in the year 7 BC. On May 29, the phenomenon was visible for over two hours and gave the effect of a new star flaring brightly. Jupiter and Saturn were at that point entering the constellation Pisces. During the following conjunctions – on October 3 and December 5 – both planets were seen in the constellation.

With this in mind, the German author Werner Keller proposed a revised interpretation of St. Matthew's Gospel. Namely, when the Magi claim they saw his star in the

Babylonian map of the world on a clay tablet dating from around 600 BC, discovered in Sippar on the bank of the Euphrates, in modern-day Iraq.

Astronomy in the ancient world

ASTRONOMY IS ONE OF THE OLDEST SCIENCES in human history. Its origins are believed to be in Mesopotamia, where the Babylonians discovered the periodicity of lunar eclipses known as the Saros cycle. They were also the first to ascertain the existence of five of the planets in our solar system. They didn't use optical equipment but merely observed the skies with the naked eye, making mathematical deductions. Consequently, they were able to predict with great accuracy a number of astronomic phenomena. Certain of these phenomena weren't visible from Earth, since they took place during the day, and yet the Babylonian astronomers knew of their existence not on the basis of observation, but on the basis of their own astral calculations. Their scientific prowess spread and developed in other ancient civilizations: in Persia, Egypt, China, India, and Greece.

Babylonian tablet with cuneiform script, recording the observation of Halley's Comet. The oldest of these kinds of astronomic records in Assyria and Babylonia date back to 3000 BC.

Map of the sky on the grave of Senenmut, Queen Hatshepsut's architect in ancient Egypt.

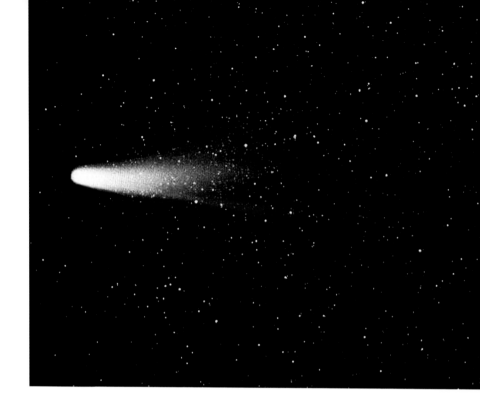

Halley's Comet *was last visible from Earth on February 9, 1986.*

East, they may have been referring not to the geographic east, but the heliacal east. In other words, they were describing a star in its rising phase, when just before dawn it first becomes visible above the eastern horizon, which they observed on May 29, when Jupiter and Saturn entered Pisces.

In those days astrologers gave specific meanings to certain celestial bodies. It was no coincidence that the planets were named for gods. Jupiter was a symbol of authority and supremacy; Saturn was regarded as the defender of Israel; the Pisces constellation was a sign of the End of Days and the beginning of a new era. It is hardly surprising, in that context, that the Magi interpreted the triple conjunction as evidence of the birth of the Messiah.

There is also much evidence to suggest that the Magi might have retained considerable contact with the Israelites then liv-

The medieval Bayeux Tapestry depicting Halley's Comet, which was visible from Earth in 1066.

ing in Persia and Babylon. From them they might have become familiar with the numerous Messianic prophecies of the Old Testament, such as Balaam's prophecy in the Book of Numbers: "I see him, but not now; I behold him, but not near: a star shall come forth out of Jacob, and a scepter shall rise out of Israel" (24:17). This description tallies with the appearance and disappearance of a celestial body, resulting from the planetary conjunction in 7 BC. Taken together, all this persuaded the Magi to set out on their journey.

Here is Keller's account of what might have taken place: "On May 29, in the year 7 BC, they observed the first conjunction of the two planets from the roof of the School of Astrology at Sippar. At that time of year the heat was already unbearable in Mesopotamia. Summer is no time for long and difficult journeys. Besides that, they knew about the second conjunction

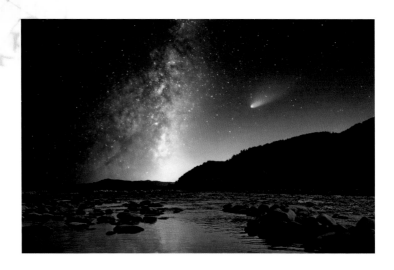

In Christian iconography, beginning in the Middle Ages, the Star of Bethlehem has traditionally been depicted as a comet. As a result, some have identified it with Halley's Comet, Comet ISON, and even the more recently discovered (2010) Comet Elenin. None of these theories has received scientific backing, however..

Dance of the spheres

A TRIPLE CONJUNCTION OF JUPITER AND SATURN in the constellation Pisces is a very rare phenomenon, which can be observed every eight hundred years or so. According to ancient records, Jupiter and Saturn appeared to align three times in 7 BC: on May 29, October 3, and December 5.

The triple conjunction of Jupiter and Saturn in the constellation Pisces in 7 BC – May 29, October 3, and December 5.

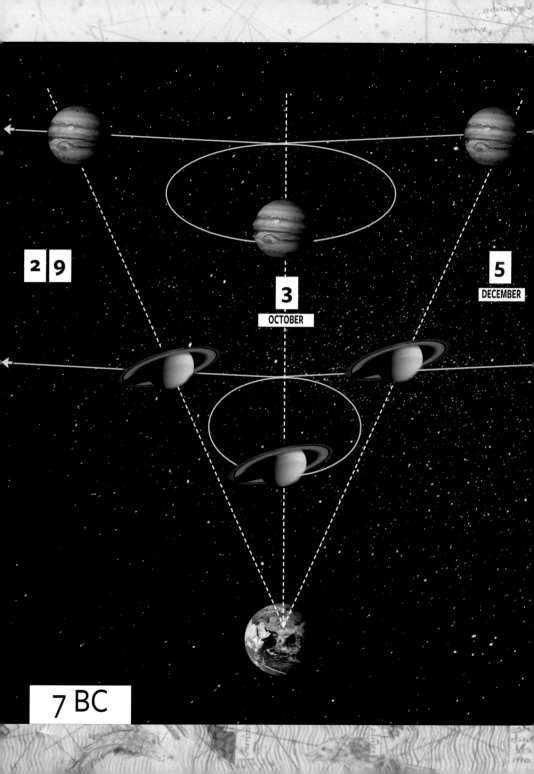

on October 3. They could predict this encounter in advance as accurately as future eclipses of the sun and the moon. The fact that October 3 was the Jewish Day of Atonement may have been taken as a sign and at that point they may have started out on their journey. Travel on the caravan routes even on camels, the swiftest means of transport, was a slow affair. If we estimate the journey lasting about six weeks, the Wise Men could have arrived in Jerusalem towards the end of November."

The German author Michael Hesemann provides a similar reconstruction: "On November 12, 7 BC, shortly before sunset, as they journeyed from Jerusalem towards Bethlehem just 10 kilometers away, they had both planets directly before their eyes. St. Matthew (2:10) might have been referring to this observation: 'When they saw the star, they rejoiced exceedingly

Astronomic relief from Dendera in Egypt (background) and a terracotta astrological disc from the Thirtieth Dynasty. Thanks to astral observations, priests in the Land of the Pharaohs were able to predict accurately such events as eclipses of the sun or the moon.

with great joy.' After astronomical twilight, the pair of planets rested at the peak of a beam of zodiacal light, which gave the impression that the light was emanating from the double star. At the same time, this beam pointed the way towards the town lying before them, whose silhouette was visible on the horizon like a paper cutout."

The American astronomer Michael R. Molnar, of Rutgers University in New Jersey, has proposed a different theory concerning the Magi and their journey to Bethlehem. In 1999, Mol-

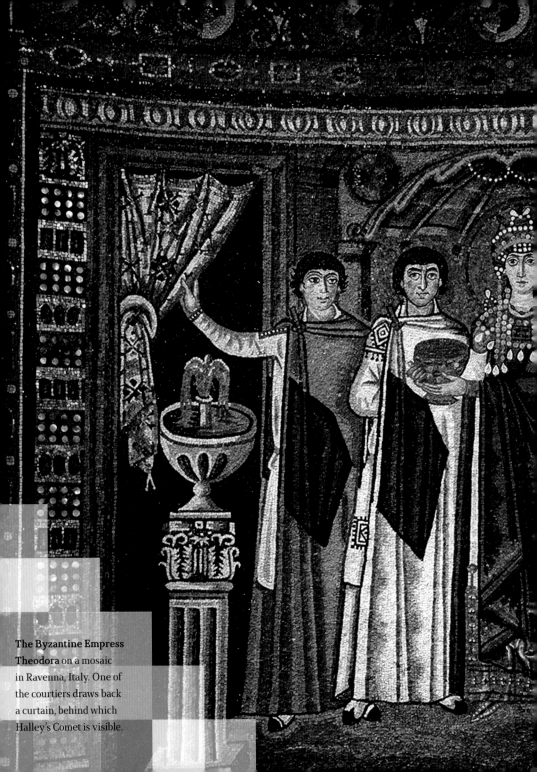

The Byzantine Empress Theodora on a mosaic in Ravenna, Italy. One of the courtiers draws back a curtain, behind which Halley's Comet is visible.

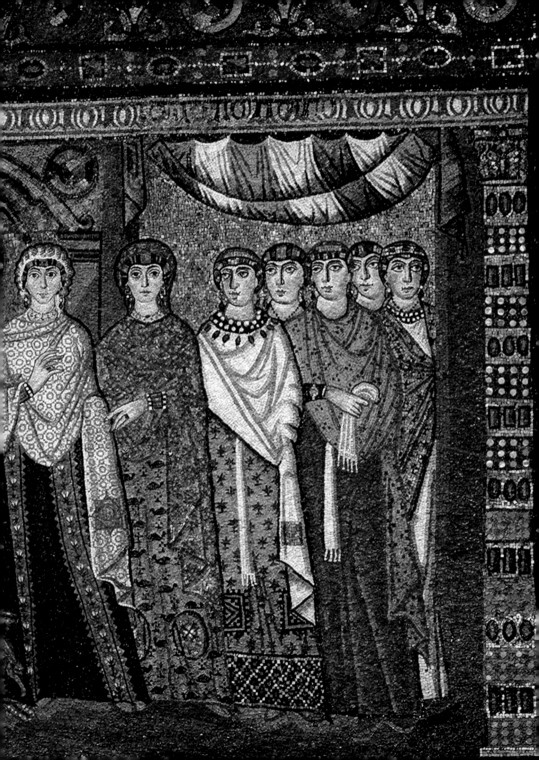

nar published a book entitled *The Star of Bethlehem*, in which he argues the Wise Men were guided by horoscope analyses more than astronomic observations. He based his theory on the *Mathesis*, a Roman astrological text composed around 344 AD by the astrologer Julius Firmicus Maternus. It is notable for containing the first extra-biblical reference to the Star of Bethlehem.

Molnar studied numerous horoscopes that would have been presented to Roman emperors by their court astrologers. He also familiarized himself with several astrological treatises of the period. From these, he ascertained that Jupiter most often symbolized a king; Judea was signified by the zodiacal sign of Aries; and the moon heralded the appearance of something, or someone, remarkable.

Molnar concluded that the birth of the King of the Jews would have been made apparent to the Magi by a conjunction of Jupiter and the moon in the constellation Aries. He decided,

Michael R. Molnar, American astronomer, author of a book about the Star of Bethlehem.

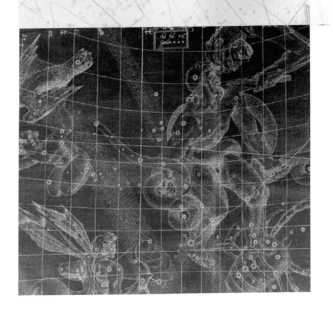

The Magi interpret the stars

JUPITER, THE STAR OF THE GREATEST BABYLONIAN DEITY, looked its brightest when conjoined with Saturn, the cosmic representative of the Jewish nation.

Konradin Ferrari d'Occhieppo

Iconographic map of the night sky with illustrated representations of the constellations.

IT SEEMS POSSIBLE that several astrologers, interpreting this unusual event (observed and recorded in Babylonia and in Egypt) as evidence of the birth of a king (Jupiter was king of the planets), set out for Judea due to its positioning as the only kingdom in all Syrophoenicia; apart from that, Saturn was for the Babylonians a sign of the Kingdom of Amurra, or Syria; finally, according to medieval Rabbinic tradition, Saturn was the star of the Jews.

Giulio Firpo

A remnant from Kepler's Supernova, an exploding star observed by the German astronomer Johannes Kepler on October 17, 1604.

therefore, to investigate whether any unusual celestial configurations had taken place between 10 and 5 BC. It turned out that on two occasions in the year 6 BC – March 20 and April 17 – Jupiter and the moon had indeed aligned in Aries. The phenomenon relies on one of these celestial bodies eclipsing the other. Jupiter was covered by the moon, before reappearing some time after. Molnar's theory has a weak point, however. While this celestial configuration did fulfill the horoscope pertaining to the new king's birth, it was completely invisible

to the human eye. The phenomenon took place around sunset, and thus would have been almost completely blocked by the resulting glare.

Yet another theory has been put forward by the British astronomer Mark Kidger, a researcher at the Astrophysics Institute of the Canary Islands. He draws attention to the fact that around the time of Christ's birth, astrologers witnessed a remarkable number of unusual celestial phenomena in a comparatively brief period of time. Indeed, in the space of just a few years, four rare phenomena took place in the skies above. The first of these was the triple conjunction of Jupiter and Saturn in the constellation Pisces in 7 BC, which was observed by astrologers in Sippar and later discovered by Johannes Kepler in the seventeenth century. The second phenomenon was the triple conjunction of Jupiter, Saturn, and Mars in Pisces, in the year 6 BC. Admittedly, this planetary alignment was not visible from Earth, but it would still have been apparent to astrologers mapping celestial movements. The third phenomenon concerns the simultaneous conjunctions that took place on February 20, 5 BC: Jupiter and the moon on the one hand, and Mars and Saturn on the other. The fourth phenomenon that Kidger mentions is a supernova – a stellar explosion which has the ability to outshine, briefly, an entire galaxy. Ancient Chinese and Korean chronicles describe how such a phenomenon was visible from earth for seventy-six days in the year 5 BC, from March to the end of May. A similar phenomenon is described in the apocryphal Protevangelium of James, which presents a narrative of Jesus' birth, among other things.

All the theories outlined demonstrate that the Star of Bethlehem needn't have been a myth or some fantastic invention. Indeed, modern-day astronomers have proved that the Wise Men may well have been drawn to Bethlehem by an unusual light in the skies above.

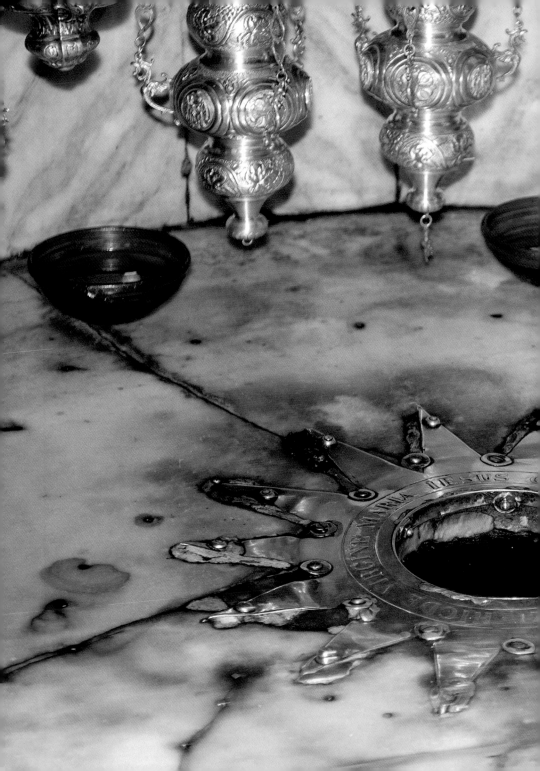

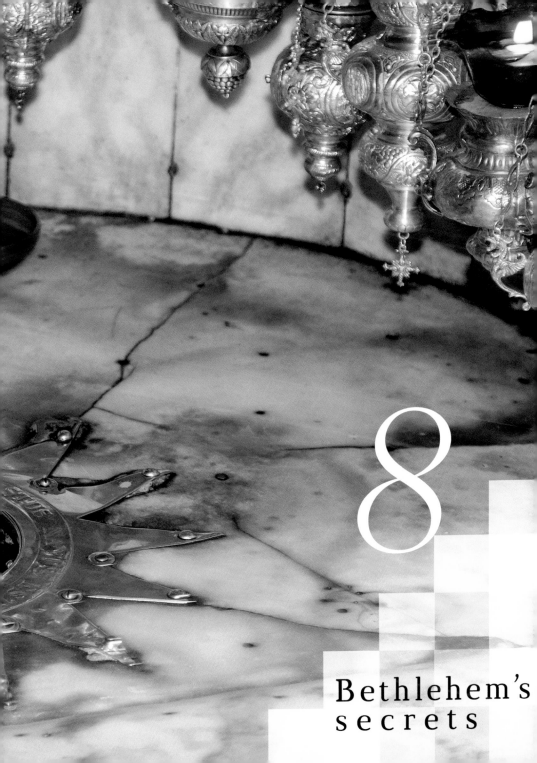

8

Bethlehem's
secrets

EIGHTH MYSTERY

BETHLEHEM'S SECRETS

When the Wise Men set off for Judea, they made their way initially to Jerusalem with the question: "Where is he who has been born king of the Jews? For we have seen his star in the East, and have come to worship him" (Mt 2:2). When this news reached Herod, he was perturbed. He summoned his chief priests and Scripture scholars to tell him where the Messiah was to be born. Herod's request betrays the fact that he was not familiar with Jewish tradition.

Silver star from 1717 in the Nativity Grotto in Bethlehem, bearing the Latin inscription "Hic de Virgine Maria Jesus Christus natus est" (Here Jesus Christ was born to the Virgin Mary).

Of Arab descent, Herod was not Jewish by birth. If he, like many other Jews, had been awaiting the arrival of the Messiah, he would have known the answer to his own question. The response of his chief priests would have been the following quotation from the Book of Micah: "But you, O Bethlehem Ephrathah, who are little to be among the clans of Judah, from you shall come forth for me one who is to be ruler in Israel" (5:2).

Bethlehem, which lies about five miles to the south of Jerusalem, was in those days home to about a thousand inhabitants. Its name – Bet Lehem in Hebrew – literally means "house of bread". The town's original name, Ephrathah, meaning "fruitful", probably derives from the fertility of the region's soil.

Bethlehem was one of the oldest Jewish settlements. It was the birthplace of Benjamin, the last-born of the twelve sons of Jacob, who was the third patriarch of Israel, after Abraham and Isaac. Benjamin's mother, Rachel, died while giving birth to him. Before her death she named her son Ben Oni, meaning "son of my pain", which Jacob later changed to Ben Yamin, usually interpreted as "son of the right hand" (or "son of the south"). Jacob buried Rachel in Bethlehem and erected a stone monument on her grave, as described in the Book of Genesis. To this day her tomb is revered by Jews, Christians, and Muslims.

The Tree of Jesse, an artistic representation of Jesus' genealogical tree, which draws on the prophecy found in Isaiah: "There shall come forth a shoot from the stump of Jesse, and a branch shall grow out of his roots" (11:1).

Bethlehem is associated with several figures described in the Book of Ruth, namely Elimelech, Naomi, and Boaz. Above all, it is notable for being the birthplace of the great ruler of the ancient Kingdom of Israel, David, the youngest of the sons of Jesse. Of course, Bethlehem was also the place where Jesus was born. To this day it is often asked whether his birth took place in a grotto or a stable. Christian tradition mentions both. But which is true? According to Fr. Bargil Pixner , the biblical archeologist and Benedictine monk, who died in Jerusalem in 2002, both versions seem to be based in truth.

It is likely that Mary would have recounted the story of Jesus' birth to those members of the early Church in Jerusalem. Consequently, knowledge of the place of Christ's birth would have been preserved. Born in the year 100 in Neapolis (formerly Shechem and modern-day Nablus in the northern West Bank), St. Justin Martyr, who called himself a Samaritan and who had

a good knowledge of Palestine, described the specific grotto in Bethlehem where Christ was meant to have been born.

In the mountainous region surrounding Bethlehem there is certainly no lack of caves and grottos, which for centuries were used by shepherds as stables. They were cool in the summer and remained warm in the winter, which suited the shepherds' flocks. The grotto where Jesus was supposedly born was quite deep. Inside, there was a cavity in the rock, which would have served as a trough, or manger, for feeding animals. Fr. Pixner believed this could have been the same manger in which Mary lay her newborn Infant, as described in St. Luke's Gospel.

In 135 AD, following the Roman suppression of the Bar Kokhba revolt, Emperor Hadrian ordered the expulsion of the Jews from Jerusalem. He decreed that buildings associated with the Jewish and Christian cults (effectively Judeo-Christian at this time) be built over or destroyed. Hence a grove above the Bethlehem

Panoramic night shot of Bethlehem.

The Bethlehem Basilica

THE CHURCH OF THE NATIVITY IN BETHLEHEM is one of the oldest continually functioning churches in the world. It was erected under the orders of St. Helena (the mother of the emperor Constantine the Great) above the grotto where – according to early Christian tradition – Christ was born. The building work, which was overseen by Bishop Macarius of Jerusalem, lasted from 327 to 333. The church was destroyed, however, in 529 during the Samaritan insurrection. It was rebuilt in 565 under Justinian the Great, emperor of the Byzantine Empire, and it has been preserved in this shape to this day. The basilica has five aisles, and grottos beneath the church have been converted into chapels. The most important of these is the Nativity Grotto, where Jesus Christ is believed to have been born.

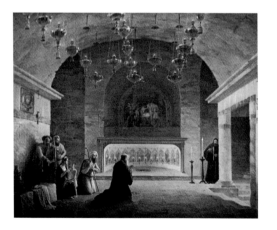

The inside of the Church of the Nativity in Bethlehem, in an illustration dating from 1833.

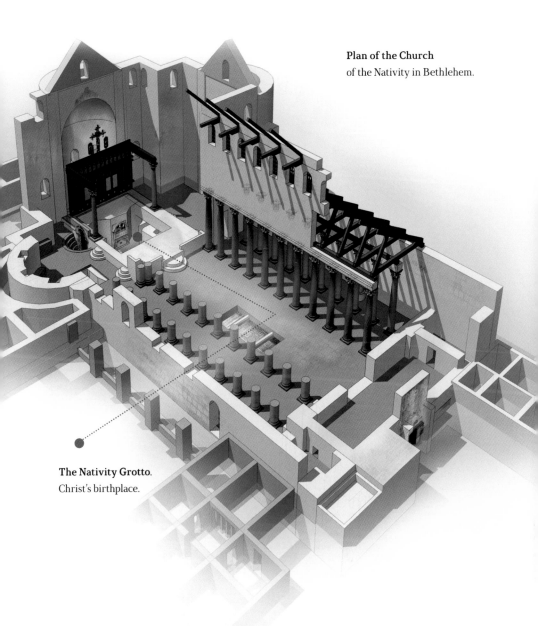

Plan of the Church
of the Nativity in Bethlehem.

The Nativity Grotto.
Christ's birthplace.

112

The Church of the Nativity in Bethlehem on a medieval
illustration dating from 1487.

In the third century, the cave was visited by Origen, one of the foremost Christian thinkers of that era. He left an account describing the much revered grotto: "This site is greatly talked of in surrounding places, even among the enemies of the faith, it being said that in this cave was born that Jesus who is worshiped and reverenced by the Christians." In 395 St. Jerome wrote a letter to Paulinus of Nola, mentioning the pagan grove: "In the very cave where the infant Christ had uttered his earliest cry, lamentation was made for the paramour of Venus."

Jerome lived in altogether different times from Origen. The situation within the Roman Empire had changed significantly following Constantine the Great's accession to the imperial throne and his conversion to Christianity. In 327, largely due to the influence of the new emperor's mother, St. Helena, work began on the Church of the Nativity, directly above the cave. Six years later, the five-aisle basilica was consecrated. To further commemorate the occasion, the grotto itself was refurbished, and the original manger replaced with one made of silver. St. Jerome lamented: "Now, as if to honor the Christ, we have removed the poor one and placed there a silver one; however, for me the one which was removed is more precious."

At about this time, hermits began settling near Bethlehem, using the local grottos as their shelters. St. Jerome was himself one of these and lived in Bethlehem from 388 to his death in 420. During this time he completed his translation of the Bible from Greek and Hebrew into Latin. This canonical text, known as the Vulgate, would be used in the Roman Catholic Church for centuries.

The Samaritan revolt of 529 resulted in the destruction of the Church of the Nativity. Byzantine forces were sent to quell the revolt, and Emperor Justinian I ordered that the church be rebuilt. The new basilica survived several incursions. The first came in 614, with the Persian

St. Jerome, one of the Church Fathers, spent his last years in Bethlehem.

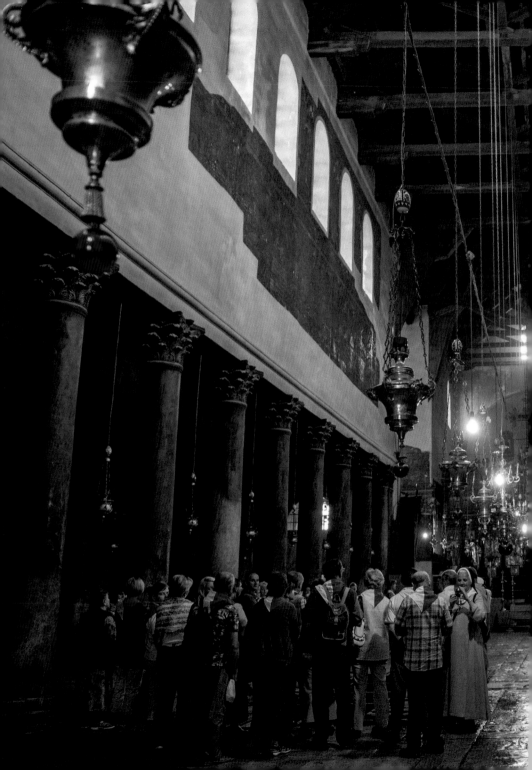

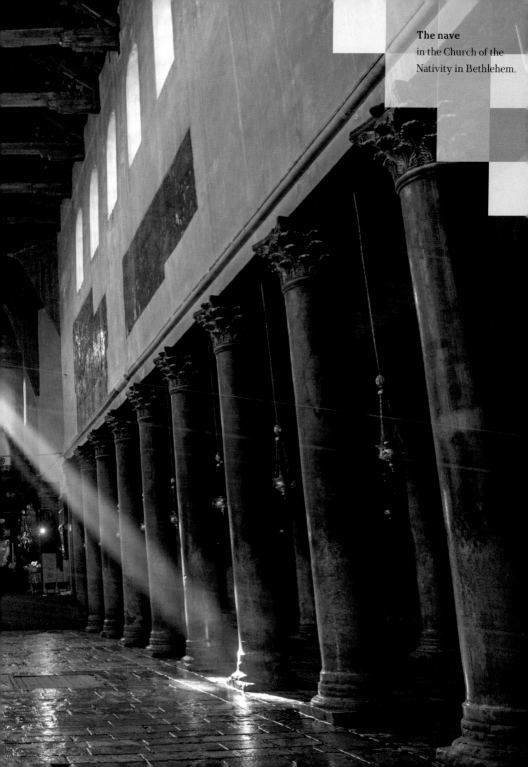

The nave
in the Church of the
Nativity in Bethlehem.

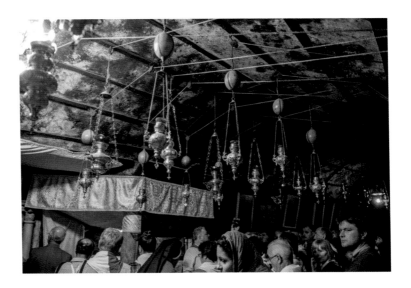

Polish pilgrims celebrate Mass in the Nativity Grotto in Bethlehem.

invasion. As mentioned, the church was spared when the invading forces noticed the depictions of the Magi on the walls. A surviving Greek chronicle states: "When the Persians arrived in Bethlehem, they saw with fear the figures of Persian magi observing the stars. Out of affection for their progenitors, they spared the church." Twenty years later, Arab forces under the Caliph Umar occupied the Holy Land, but again the basilica was unharmed. Neither was it destroyed by the fanatical Caliph Al-Hakim, who desecrated the Church of the Holy Sepulcher in Jerusalem in the eleventh century. And yet again, it was left untouched by the Mamluk Sultan Baybars, even though he razed the town of Bethlehem to the ground in 1263.

From 638, when Caliph Umar – who was father-in-law to the prophet Muhammad – occupied Jerusalem, Bethlehem likewise found itself under Islamic rule. The situation changed a few times during the Crusades, and the town was controlled by Christian knights in 1099–1187 and again in 1229–1291. When it fell back into the hands of the Muslims, they permitted Christians to worship in the Church of the Nativity. The church was looked after by Orthodox, Armenian, and Catholic monks, the latter group taking over in 1333 under the Franciscans.

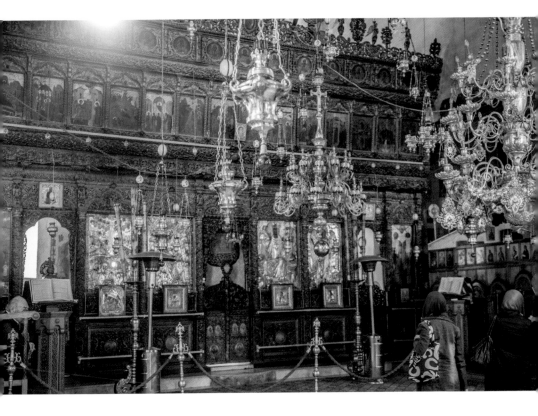

Orthodox iconostasis in the Church of the Nativity in Bethlehem.

Between 1517 and 1917, Palestine, including Bethlehem, was governed under the Ottoman Empire. However, the Turks lost this territory to the British following the First World War. An increasing number of Jews began settling in the Holy Land in the interwar period. Inspired by the Zionist movement, and after eighteen centuries of exile, they wanted to create their own nation, on the historic territory of their ancestors. They succeeded in 1948, with the creation of an independent State of Israel.

It is against this background that the Palestinian-Israeli conflict has been played out over the last few decades. On a number of occasions (such as in 1948, 1967, and 1973) Israel found itself at war with neighboring Arab states. The Jewish nation has been victorious on each occasion, however. The period between 1987 and 1993 witnessed the First Intifada, or Palestinian uprising, against the

117

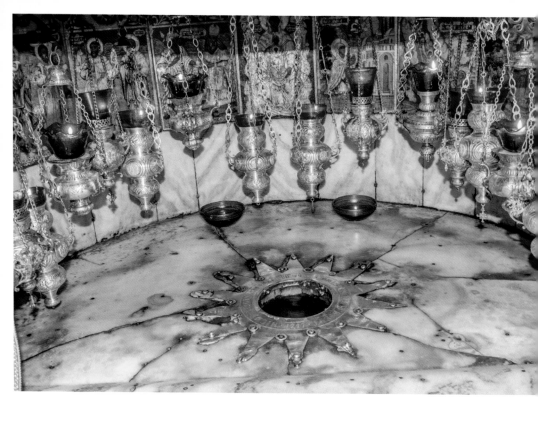

The Nativity Grotto is visited by pilgrims
from all over the world.

Israeli occupation of Palestinian territories. It resulted in the founding of the Palestinian Authority, which gave the Palestinians some measure of self-government and autonomy.

Over the last few decades, Bethlehem has been affected by the Israeli-Palestinian conflict. In 1948, it was captured by Jordan during the Arab-Israeli War. In the Six-Day War of 1967, Bethlehem was taken over by Israel. In 1995, it was turned over to the Palestinian Authority. As a result of continued fighting between both sides, Israel decided to construct the West Bank barrier between itself and the Palestinian territories. In 2006, Bethlehem was separated from Israel by a twenty-six-feet-high cement wall, which prevents regular access to Jerusalem and other places Bethlehem residents need to go.

Pilgrims who make their way to Bethlehem today therefore find themselves in a nearly enclosed town. Apart from the Church of the Nativity, another popular destination is the Milk Grotto, located about two hundred yards from the Nativity Grotto. According to early Christian tradition, this is the site where the Holy Family supposedly prepared themselves for their escape into Egypt. The grotto is so named because a few drops of milk are believed to have

The Milk Grotto in Bethlehem

NEAR THE NATIVITY GROTTO in Bethlehem lies the Milk Grotto. It is believed to be the cave where the Holy Family stopped for the night during their escape into Egypt. While nursing Jesus, a drop of milk from Mary's breast fell on the rock face, which – legend has it – turned milky white in color.

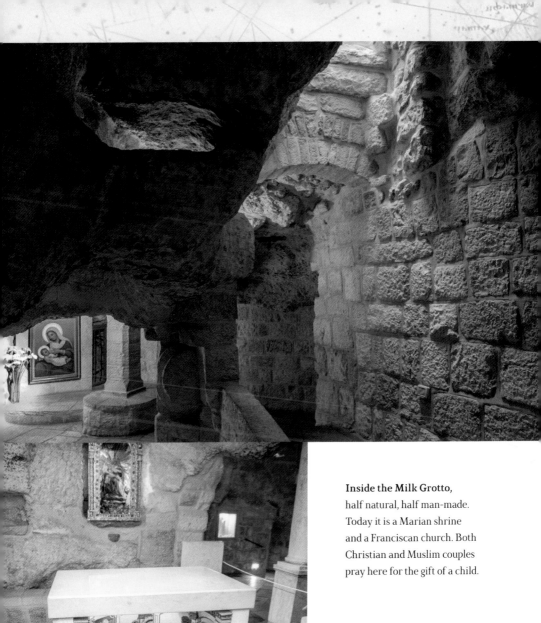

Inside the Milk Grotto,
half natural, half man-made.
Today it is a Marian shrine
and a Franciscan church. Both
Christian and Muslim couples
pray here for the gift of a child.

fallen on a rock in this place while Mary was nursing her infant Son. Legend has it that the ground and the walls turned white as a result.

These days, Bethlehem is a popular pilgrimage destination for couples who are unable to have children. They arrive at the Milk Grotto and pray to Mary for her intercession; they scrape white flakes from the walls of the cave, later drinking the stone powder after mixing it with water. Nearby there is a display showing photographs of children who were conceived after their parents came to offer prayers at the grotto.

Let us return to the Gospel. St. Luke wrote that the shepherds, who were keeping their flocks nearby, ran to worship Jesus, who was lying in a manger. They must have made their way to a grotto that served simultaneously as a stable. But where did the Magi meet Christ for the first time? Did they go to the same place? St. Matthew wrote: "And going into the house they saw the child with Mary his mother; and they fell down and worshiped him" (Mt 2:11). Significantly, the Evangelist wrote "house" and not "grotto" or "stable". The evidence suggests that

The Milk Grotto attracts couples from all over the world who are unable to have children.

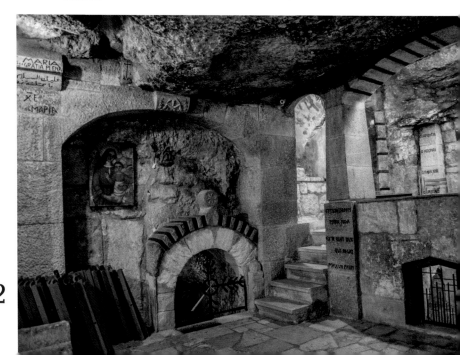

122

The ox and the ass

A FREQUENT MOTIF OF NATIVITY ICONOGRAPHY
is the scene where various animals – the ox and the ass
in particular – adore the newborn Child lying in a manger.
The choice of these animals was not coincidental, as in biblical
tradition the ass symbolized the Jews, while the ox stood for
the pagan Gentiles.

the Wise Men did not greet Jesus immediately after his birth. In all likelihood they arrived in Bethlehem after the Presentation of Jesus in the Temple in Jerusalem, which took place forty days after his birth.

Matthew wrote that the Magi found the "child"; specifically he uses the Greek word *paidon*, which is a broad term that can mean a slightly older child, as opposed to a newborn infant. Herod, wishing to kill Jesus, ordered the murder of "all the male children in Bethlehem and in all that region who were two years old and under, according to the time which he had ascertained from the Wise Men" (Mt 2:16). We can surmise, therefore, that the Magi came to Bethlehem when Jesus was already a few months old, and maybe even over a year old. No wonder, in that case, that they found him in a home rather than a stable. After all, many of Joseph's relatives, whose ancestry dated back to David, lived in Bethlehem.

The adoration of the shepherds before Mary and her Child. The Museum of the Life of Christ in Fatima, Portugal.

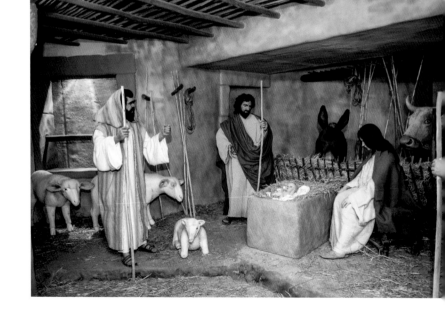

Myrrh, or lumps of fragrant resin, obtained from the commiphora tree.

We read in Matthew's Gospel that the Magi "fell down and worshiped" Jesus. Such prostration (*proskynesis*) was usually reserved for two occasions: bowing before a figure of authority and bowing before idols in worship. Their actions clearly suggest that the Magi believed Jesus to be a king. St. Gregory Nazianzen wrote that in the moment the Magi were prostrating themselves before Christ, astrology ended. Pope Benedict XVI expressed the same argument thus: "It is not the star that determines the child's destiny, it is the child that directs the star."

The Magi brought the Christ Child three gifts: gold, frankincense, and myrrh. Each one of these treasures symbolized an aspect of Jesus' mission. Gold was given to a king, frankincense to a priest, and myrrh to a prophet.

Gold represents splendor, wealth, and majesty befitting a monarch. Indeed, this precious metal has always been associated

125

Manger relics

THE SACRA CULLA, or Holy Manger. Relic venerated as Jesus' manger, in the Santa Maria Maggiore Basilica in Rome. It arrived in the Eternal City during the papacy of Theodore I (642–649), who received it from the patriarch of Jerusalem St. Sophronius. In this way, the relic would have been protected from Muslim invaders. Scientific tests have revealed that the manger is made of five maple laths, aged around two thousand years and originating in Palestine.

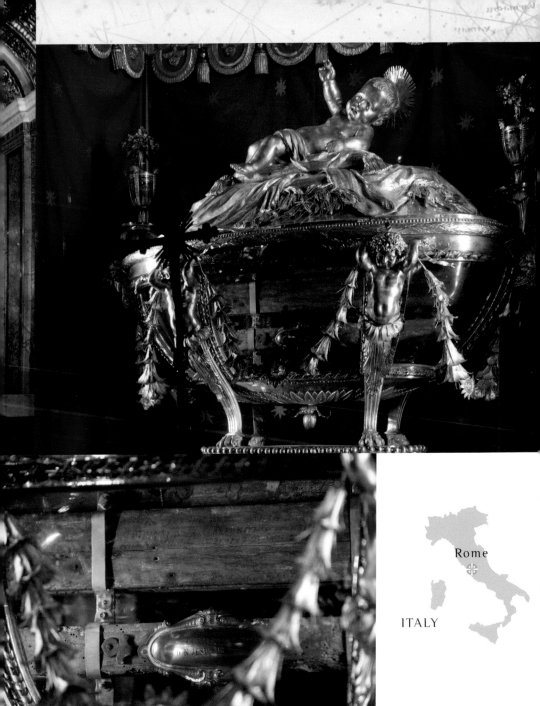

Rome

ITALY

Frankincense tree growing in the desert – the source of the raw material for making frankincense.

with kingly power. Frankincense was often used during religious rituals. It served to incense a temple, in particular an altar. Lumps of aromatic resin extracted from the frankincense tree (boswellia sacra) were burned for this purpose. In the Old Testament, the use of frankincense is specified for the worship of God. Myrrh is the aromatic resin of trees in the commiphora family. It was used to make incense, perfume, and oils to anoint the body. It symbolized mortification, purity, abstinence, and protection from decay.

Bethlehem traditionally was under the command of the tribe of Judah, from whom King David was descended. Prophets of the Old Testament foretold that the Messiah would come from the tribe of Judah, the rod of Jesse, and the house of David. This

Myrrh resin dripping down from an incision in a tree.

Ancient bowl made from gold.

genealogical prophecy serves as an argument in support of the authenticity of Jesus' messianic mission.

For the ancient Israelites, genealogy played an incomparably larger role in daily life than it does today. Genealogical records of all the Jewish tribes were preserved in the Temple of Jerusalem. If they were destroyed, it would be very difficult to prove whether or not someone claiming to be the Messiah was in fact descended from the house of David. This was regarded as an essential and prophesied condition of messianic status. In 70 AD, the Temple was destroyed by the Romans, and all genealogical records vanished. From that point onwards, conducting a genealogical test became impossible. The supposition therefore stands: either the Messiah appeared in the world before 70 AD, or the Old Testament prophecies are false.

The case
of King
Herod

9

NINTH MYSTERY

THE CASE OF KING HEROD

One of the key figures in the story of Jesus' childhood, as related by St. Matthew, is King Herod the Great. Even though he became a Jewish king, he himself was not a Jew. He was born in 73 BC, into an affluent Judean family. His father, Antipater, was an Idumean (or Edomite) Arab, while his mother, Cypros, was a Nabatean Arab.

Herod the Great – the greatest builder in ancient Israel.

Herod had no rights to the crown, succession to which was based on heredity. For this reason, the majority of Israelites deemed him a usurper, as well as a collaborator, since he worked in the service of the Roman occupiers. No wonder he felt somewhat uneasy on the Jewish throne, constantly tracking conspiracies, sniffing out assassination attempts, and suspecting even his relatives and closest confidants of treason.

If not for the diplomatic talents of his father, Herod would never have become king. Antipater made a staggering career for himself in Jerusalem: he became an advisor to the Jewish high priest Hyrcanus II, and later Roman procurator of Judea. He also earned the favor of Julius Caesar, whom he helped in his war against Cleopatra in Egypt. Consequently, he was granted Roman citizenship and permission to appoint his son, Herod, governor of Galilee in 47 BC.

Herod would eventually surpass even his father, in terms of his facility in political maneuvering among some of the ancient world's most powerful rulers. He won favor with Julius Caesar, Gaius Cassius, Mark Antony, and Emperor Tiberius. Their protection ensured he was able to remain in

Tyre

Nazareth

GALILEE

Ceasarea

Samaria
(Sebaste)

SAMARIA

Jericho

Jerusalem
Bethlehem

JUDEA

Dead Sea

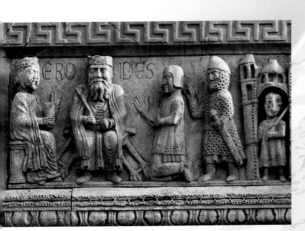

The Magi from the East talking with Herod in Jerusalem.

IDUMEA

power for thirty-three years, despite being hated by much of the Jewish populace. He was declared king of Judea by the Roman Senate in 37 BC and ruled until his death in 4 BC. Why did the Senate decide to appoint a local satrap to the Judean throne? It is worth remembering that Pompey's capture of Judea in 63 BC resulted in thousands of deaths, and the Jews were known to be a particularly defiant people. It was reckoned, in all likelihood, that in a vassal state a local ruler would be able to handle the difficult task of pacifying the local population.

Herod became renowned as the greatest builder in the history of ancient Israel. He ordered the construction of such monumental buildings as the palace-fortresses at Masada and Herodium, and Herod's Palace and the Antonia Fortress in Jerusalem. His greatest architectural accomplishment was probably the reconstruction of the Second Temple of Jerusalem, which had been built to replace the Temple destroyed by Babylonian King Nebuchadnezzar II in 587 BC.

Coins with Herodian representations minted in Judea in the first century BC.

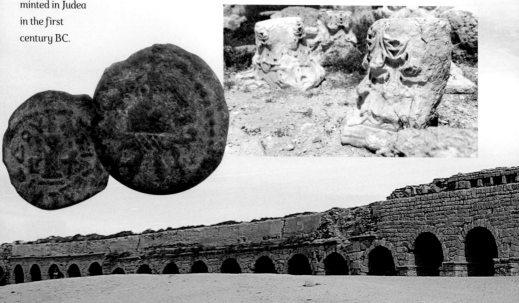

Ruins of Caesarea – where Herod ordered the construction of a temple to Augustus.

The new Temple became the pride of all orthodox Jews, though by no means did it signify that Herod himself was a devout follower of the Jewish faith. After all, he also ordered the construction of three pagan temples to Augustus. Essentially, to him all gods were nonexistent. The throne in Jerusalem was the most important thing in Herod's mind. Indeed, he was madly obsessed with power.

Herod stopped at nothing in his bid to seize the crown. In order to guarantee the legitimacy of his rule, he dismissed his first wife, Doris, and married Mariamne – the granddaughter of a high priest of the

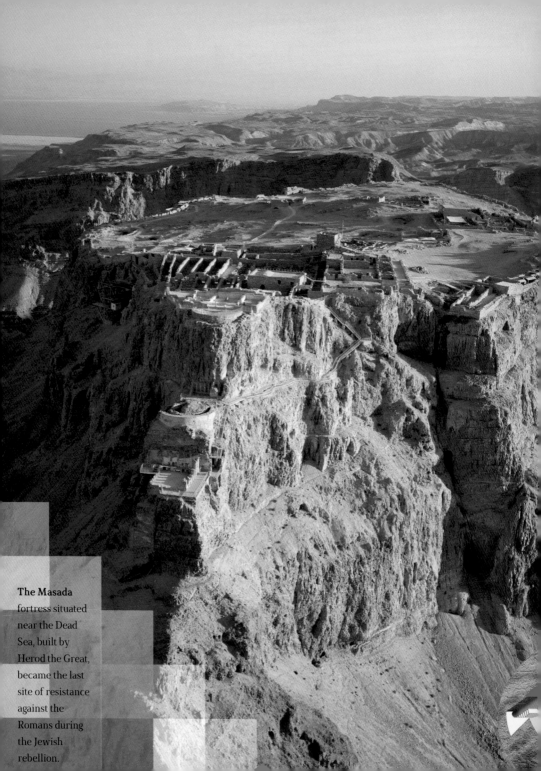

The Masada fortress situated near the Dead Sea, built by Herod the Great, became the last site of resistance against the Romans during the Jewish rebellion.

Temple of Jerusalem and Hasmonean king of Judea. He then ordered the drowning of his wife's brother, Aristobulus, and was responsible for the murders of his uncle and mother-in-law. Not even Mariamne escaped execution – it would seem Herod's love for her was outweighed by suspicion of her infidelity. She was executed along with his son-in-law Joseph, whose loyalty he was likewise uncertain of.

Mariamne bore Herod five sons, two of whom – Alexander and Aristobulus – survived childhood. However, they were both murdered after their father accused them of high treason. They were killed along with thirty soldiers. Four days before his death, and seriously ill, Herod ordered the execution of his son (by Doris), Antipater. Hearing of this, the Emperor Augustus supposedly said: "It is better to be Herod's swine than his son." The implication being that since pigs were regarded as unclean by Jews, they would not be eaten and had a greater chance of survival than the king's own progeny.

Herod's other great passion was sex. He had ten wives who bore him fourteen children. He also had a number of concubines. He became known for the debauched orgies he held in his palace.

His obsession with holding on to power deepened as he became more seriously ill in the last three years of his life, especially as

Eusebius of Caesarea wrote a history of the Church in the first half of the fourth century.

Model of Herodium, or Herod's palace-fortress.

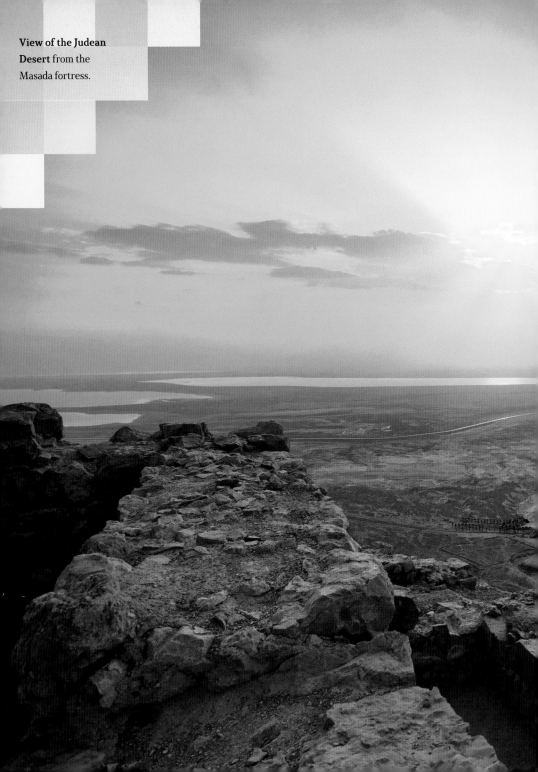

View of the Judean Desert from the Masada fortress.

plots to overthrow him became more frequent. Both Eusebius in his history of the Church and Josephus in his *Antiquities of the Jews* described Herod's agonizing final illness as a judgment from God.

Here are the details recorded by Josephus: "A fire glowed in him slowly, which did not so much appear to the touch outwardly, as it augmented his pains inwardly; for it brought upon him a vehement appetite to eating, which he could not avoid to supply with one sort of food or other. His entrails were also ex-ulcerated, and the chief violence of his pain lay on his colon; an aqueous and transparent liquor also had settled itself about his feet, and a like matter afflicted him at the bottom of his belly. Nay, further, his privy-member was putrefied, and produced worms; and when he sat upright, he had a difficulty of breathing, which was very loathsome, on account of the stench of his breath, and the quickness of its returns; he had also con-vulsions in all parts of his body, which increased his strength to an insufferable degree."

Bronze model reconstructing the view of the Masada fortress from the time of Herod's reign. Right: Herod's tomb and sarcophagus, discovered in 2007 by the Israeli archeologist Ehud Netzer.

As he lay on his deathbed, Herod was tormented by the thought that the Jews would rejoice in his death, rather than lament him. He decided, therefore, that the day he died would be a day of grieving, whether the Jews liked it or not. He ordered for the representatives of the most eminent Jewish families to present themselves at his palace in Jericho. Next, he had them arrested and incarcerated in the hippodrome. There, Herod commanded, they would be slain by foreign mercenaries upon his death. After the king died, however, the plan was called off by his sister, Salome.

In 2002, a team of medics meeting at the annual Clinical Pathology Conference decided to determine the cause of Herod's death. This initiative was built on an earlier one, dating to 1995, when a number of professors decided to reconstruct the circumstances surrounding the deaths of famous people on the basis of available historical material and accounts. A committee was formed to examine the fates of such figures as Alexander the Great, Emperor Claudius, Ludwig van Beethoven, Wolfgang Amadeus Mozart, General George Custer, and Edgar Allen Poe.

During a conference in Baltimore that same year, Jan Hirschmann from the University of Washington

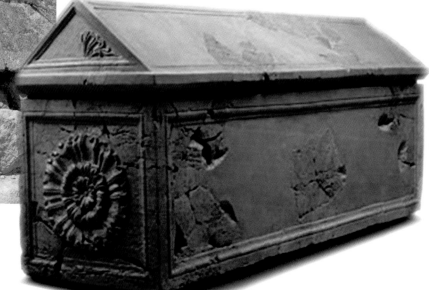

Herod the Great – the great tyrant

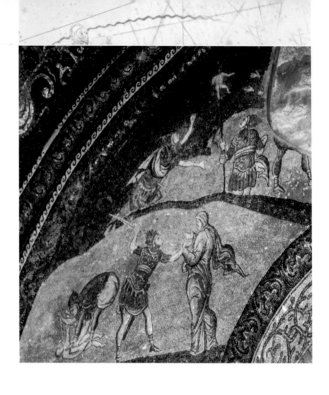

Slaughter of the Innocents, mosaic from the Church of the Holy Savior in Chora, Istanbul, Turkey (formerly Constantinople). On December 28 (Feast of the Holy Innocents), the Church commemorates the children murdered by order of King Herod.

NOW SOME THERE are who stand amazed at the diversity of Herod's nature and purposes; for when we have respect to his magnificence, and the benefits which he bestowed on all mankind, there is no possibility for even those that had the least respect for him to deny, or not openly to confess, that he had a nature vastly beneficent; but when any one looks upon the punishments he inflicted, and the injuries he did, not only to his subjects, but to his nearest relations, and takes notice of his severe and unrelenting disposition there, he will be forced to allow that he was brutish, and a stranger to all humanity;... the occasion of both these sort of actions was one and the same; for being a man ambitious of honor, and quite overcome by that passion, he was induced to be magnificent,... and as his expenses were beyond his abilities, he was necessitated to be harsh to his subjects.

Flavius Josephus

in Seattle presented the diagnosis that Herod died from chronic kidney disease, brought on by Fournier gangrene. The diagnosis tallies with all available descriptions of the Judean king's illness, with symptoms including intense itchiness, bowel pain, shortness of breath, convulsions, and putrefaction of the genitals. This sort of kidney disease can also have an effect on the brain, which might, to an extent, explain the king's increasing cruelty.

In St. Matthew's Gospel, Herod ordered the murder of all male children age two and under in and around Bethlehem after the birth of Christ. However, not a single contemporary historian recorded the massacre of the innocents. Not even the chronicler Josephus, who wrote extensively about Herod the Great, mentioned it. This was enough for some theologians (such as Gerhard Pause and Jürgen Roloff) to declare that the biblical narrative of the slaughter had been invented.

The fact that only Matthew mentioned the massacre does not necessarily mean it never took place. In the words of German journalist Peter Seewald: "The number of male children under the age of two who were murdered in Bethlehem might have been between ten and forty, which for Josephus would have been relatively few when compared with the heaps of dead

King Herod, according to St. Matthew, ordered the murder of all male children age two and under in Bethlehem and its vicinity.

143

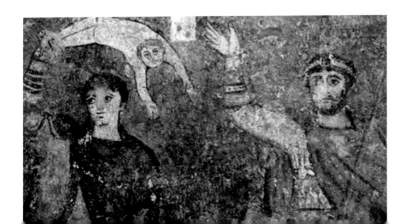

Massacre of the Innocents, fragment, painted by Lucas Cranach the Elder around 1515, Warsaw National Museum.

registered in the course of Herod's reign. One must also concede that Josephus neglects to mention other atrocities. During Jesus' youth, two thousand rebels were crucified in Seforis, near Nazareth, by the Roman general Quinctilius Varus, as an act of retaliation. While this isn't mentioned in Josephus' writings, it isn't questioned by any historians today."

It is also worth noting that the year in which the massacre of the innocents was to have taken place also marked the greatest escalation in the number of executions. Josephus recalled that the Pharisees' messianic prophecies enraged Herod so much, that in 7 BC he ordered the murder of six thousand people. Compared with this hecatomb (which in the words of German archeologist Gerhard Kroll "spread over all Jerusalem like a funereal pall"), the murder of a few dozen children in Bethlehem may

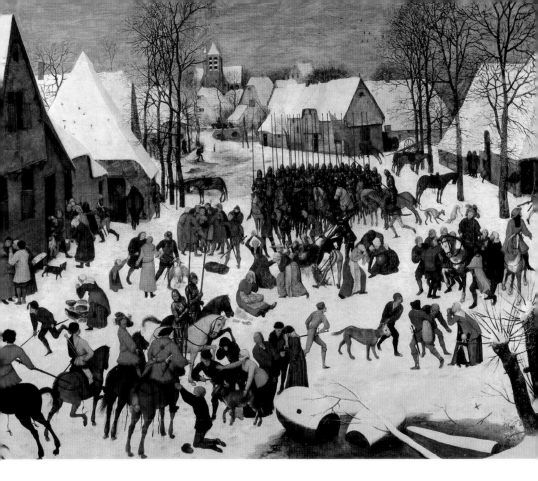

Massacre of the Innocents by Pieter Bruegel the Elder, painted in 1566 and kept in the Viennese Kunsthistorisches Museum.

not have been a significant episode for chroniclers, when placed in the context of Herod's gory biography.

The massacre of the innocents corresponds exactly with the sort of psychological portrait we have of Herod, especially concerning his manic paranoia and obsession with power. In the light of all we know about this tyrant, his actions as related by St. Matthew seem rather likely.

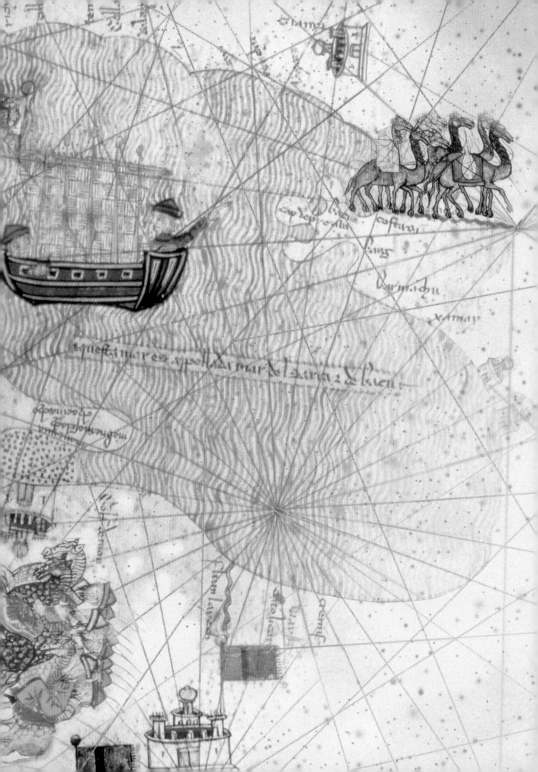

10

The oldest
feast

TENTH MYSTERY

THE OLDEST FEAST

Why is the Epiphany, or the Manifestation of Christ, the oldest of all the feast days instituted by the Church? These days it commemorates the Adoration of the Magi, but in ancient times it represented a number of events simultaneously: Christ's birth; the arrival of the Wise Men; Jesus' baptism in the River Jordan; and the Wedding at Cana, where Christ performed his first miracle.

Byzantine mosaic in the Church of the Holy Savior in Chora, Istanbul, depicting the miracle at the Wedding in Cana.

The feast was used to mark Jesus' gradual revelation to the world – a world described in some depth by St. Clement of Alexandria, who died in 212 AD.

In the Roman Church, the Epiphany began to be celebrated separately from Christmas only after the end of the fourth century. Later, Christ's baptism and the Wedding at Cana were also given separate dates in the liturgical calendar. The Feast of the Epiphany, which in time also became known as the Feast of the Three Kings, would be celebrated on January 6. The day recalled the manifestation of God to the Gentiles, represented by the Magi. In them, the early Church rediscovered itself in the context of a pagan world, for whose salvation God became man. The feast was supposed to highlight Christianity's universality, being aimed at people of all races, cultures, languages, and nationalities. In the words of St. Augustine: "Who were the Magi but the first fruits of the Gentiles? The shepherds were the Israelites, the Magi, Gentiles. The one group came from nearby; the other, from afar. Both, however, were united in Christ the cornerstone."

The Magi were pilgrims, seeking the truth, prepared to set out for the unknown to come to know God. They represent

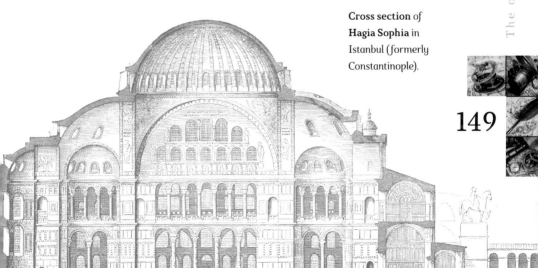

Cross section of **Hagia Sophia** in Istanbul (formerly Constantinople).

149

Władysław II Jagiełło adores before Mary and the Child Jesus. Painting in the castle chapel in Lublin, Poland.

wealth and power, and yet they prostrated themselves before an infant. In doing so, they acknowledged a certain hierarchy where that which is spiritual and eternal is more valuable than that which is earthly and mundane.

The story of the Adoration of the Magi became one of the most popular of the New Testament. The scene of their veneration of the Christ Child is one of the most commonly employed iconographic motifs in Christian art. Christian medieval rulers often depicted themselves as one of the Wise Men, thereby demonstrating their piety and ardent devotion to Christ.

One of the most well-known examples of this can be found on a Byzantine mosaic in the Hagia Sophia in Istanbul (formerly Constantinople). There, two monarchs are shown bearing gifts to Mary and her Son. On the right, Constantine the Great offers

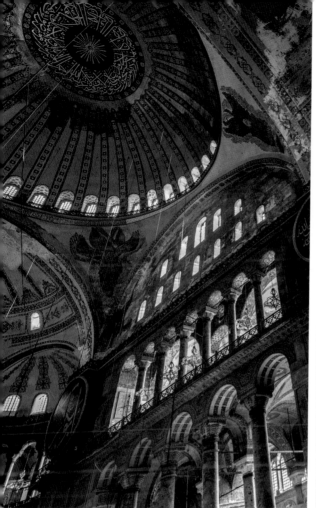

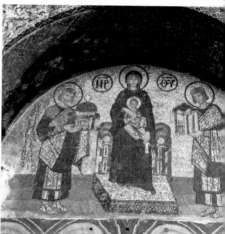

Byzantine mosaic in Hagia Sophia in Istanbul, depicting
Constantine's and Justinian's adoration of the Holy Mother and Child.

his city of Constantinople, while on the left, Emperor Justinian
offers Hagia Sophia.

In the West, a pertinent example is the Wilton Diptych,
commissioned by King Richard II at the end of the four-
teenth century. The right panel shows the Madonna with Child

The Cathedral of
St. Peter and St.
Mary, situated on
the Rhine in Cologne,
Germany, built
between 1248 and
1880.

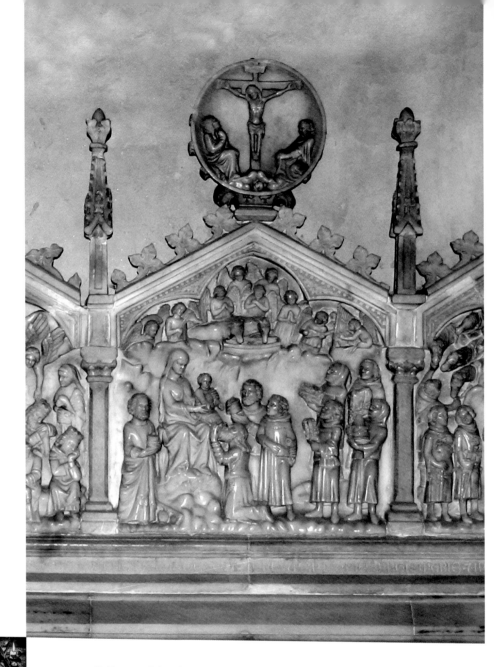

Reliquary of the Three Kings in Milan, Italy – in the basilica's right nave, is an ancient Roman sarcophagus traditionally said to contain the remains of the Three Magi.

surrounded by eleven angels bearing a flag with the cross of St. George. The left panel shows the kneeling king, with three saints standing behind him: John the Baptist and the English Kings Edmund the Martyr and Edward the Confessor. On his knees and with hands outstretched, King Richard looks as if he were expecting Mary to hand the Child to him. In this way, the anonymous artist presents Richard's desire to accept Christ – in other words, to receive the sacrament of the Eucharist. The scene of the Adoration of the Magi was already held in high esteem by the king, as he himself was born on January 6 – the Feast of the Epiphany – in 1367. This resonates with his decision to be portrayed as one of three English monarchs offering the Kingdom of Albion to Jesus.

The medieval European site most associated with the cult of the Three Kings is Cologne, Germany. In 1163, German King and Holy Roman Emperor Frederick Barbarossa occupied Milan, Italy, and took three skeletons, believed to be the relics of the biblical Magi, from the Basilica of St. Eustorgius. The relics were believed to have been brought to Constantinople in the fourth century by Constantine's mother, St. Helena. Next they were moved to Milan, where they remained until Frederick Barbarossa's invasion.

The emperor, of the Hohenstaufen dynasty, took the relics with him to Cologne under the advice of the town's archbishop Rainald of Dassel. It was decreed that a special chapel would be built to house the relics. However, with more and more pilgrims traveling to see the holy remains every year, it was decided that a larger space would be needed to accommodate them. When the old cathedral burned down in 1248, a new Gothic cathedral was built in its place.

A public display of the Three Kings relics takes place in Cologne Cathedral once a year.

The Three Kings Reliquary in Cologne is made up of three sarcophagi, which form a miniature basilica.

Building continued on and off for six hundred years, and the cathedral was finally completed in 1880. The resulting edifice is imposing: the monumental cathedral of St. Peter and St. Mary is a gem of European Gothic architecture, and the most impressive church of its kind in all of Germany. Thanks to its prized relics, Cologne became – along with Rome, Santiago de Compostela, and Aachen – one of the most important pilgrimage sites in Europe. Its significance grew especially following the fall of the Crusader state of the Kingdom of Jerusalem in 1291. Instead of setting out on the rather dangerous journey to Muslim-occupied Jerusalem, pilgrims from Germany, France, and England settled instead for Cologne, where they hoped to find at least a substitute for the real Bethlehem.

The cathedral's most valuable possession is still the Reliquary of the Three Kings – a medieval masterpiece wrought by Nicholas of Verdun at the turn of the thirteenth century. Made of wood, then gilded, it is lined with silver and encrusted

Cologne Cathedral is the
second-highest Gothic church
in the world (after Ulm
Minster), its tower reaching
516 feet. It is one of the largest
cathedrals in the world.

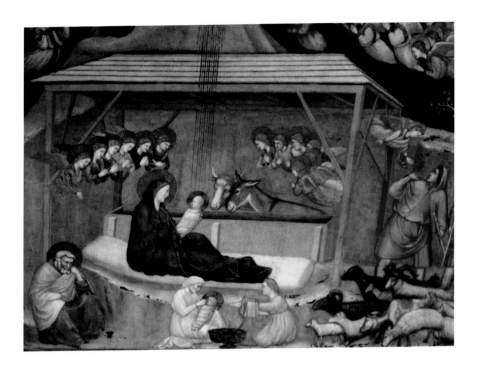

Nativity creche at St. Peter's in Rome, and a fresco depicting the Nativity in a basilica in Assisi.

with over a thousand precious stones. Constructed of three sarcophagi, it is shaped like a basilica. The outside of the reliquary is decorated with images of biblical scenes, along with reliefs of prophets and apostles.

Since the thirteenth century, the Three Kings have been incorporated into Nativity scenes (figurines showing the birth of Jesus), which themselves derive from medieval Franciscan mystery plays. Indeed, St. Francis of Assisi is credited with having created the first Nativity scene, in 1223 at Greccio, Italy, with living people and animals.

The tradition of blessing gold and frankincense on the Epiphany came about at the turn of the seventeenth century. Incense made of juniper resin was used to bless houses and farmsteads. The eighteenth century witnessed the start of another tradition – the blessing of chalk, which was then

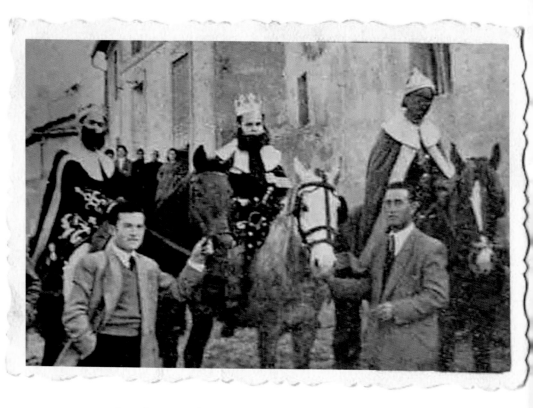

In modern times the tradition of organizing Three Kings parades originated in Spain.

used to write "C+M+B" and the year above the thresholds of people's homes. Various interpretations exist for this practice: the initials could stand for "Christus Manisionem Benedicat" (Christ bless this house) or "Christus Multorum Benefactor" (Christ the benefactor of many), but they have more often come to represent the names of the Wise Men themselves, namely Caspar, Melchior, and Balthasar. The custom echoes the Exodus story in which the Jews marked their thresholds with the blood of the paschal lamb so that the Angel of Death would pass over their homes. For Christians, the chalk initials

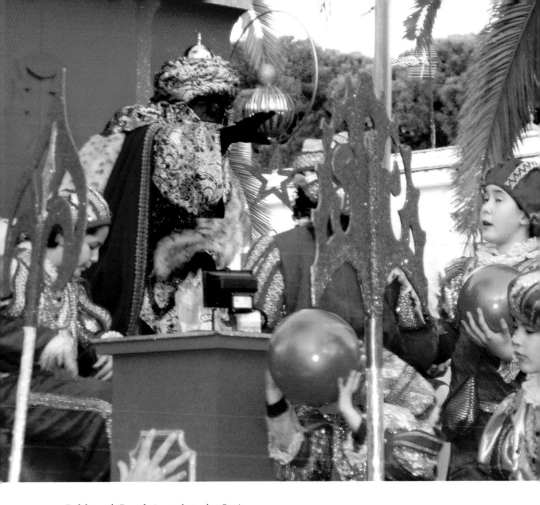

Balthasar's Parade in modern-day Spain.

amount to a public declaration of faith, as well as a request for God's blessing.

The Spanish tradition of organizing a Three Kings parade began in the nineteenth century and involves a procession through the streets, led by individuals dressed as figures from the Nativity. The oldest of these took place in Alcoy in 1866. Since that time, other cities have taken up the custom, with Seville and Granada often providing the most sumptuous examples.

In Poland, Epiphany was always one of the most important religious festivals and a public holiday. This ceased to be the case in 1960, after the Communist government made Epiphany illegal. After the fall of Communism, public initiatives attempted to reinstate the feast day to its former importance. These efforts were rewarded in 2011, from which time January 6 has, once again, been deemed a public holiday.

Today we are witnesses to a new tradition, which nevertheless has its roots in the oldest of Christian practices. Poles increasingly wish to participate in a communal and authentic celebration of Epiphany. This has taken the form of a parade, the first of which was instituted in Warsaw in 2009. Over the following years, Three Kings parades have begun in a number of other towns and cities. In 2014, seven hundred thousand people took part in processions, organized across one

Since 2009, the Three Kings parade has wound its way through the streets of central Warsaw.

The number of Three Kings parade participants in Polish towns is estimated at hundreds of thousands each year.

hundred seventy-seven Polish towns. The custom has spread to other countries, including Ukraine, Germany, Italy, the United States, and even the Central African Republic.

The living tradition embodied by the Three Kings parade speaks of a deeply held desire, lying in the hearts of people today. It is the same desire that prompted the Magi to leave their homes and set out for Bethlehem two thousand years ago. This need for truth and understanding, essentially a need for God, is described by St. Augustine in his *Confessions*: "You have made us for yourself, O Lord, and our heart is restless until it rests in you."

163

In recent years, the Feast of the Epiphany has become a public display of faith in Poland.

Select Bibliography

Augustine. *The Confessions*. New York: Image Books, 1960.

Badde, Paul. *Ziemia Boga w 20 tajemnicach*. Translated by Marcin Masny. Bytom, Poland: Niecałe Wydawnictwo, 2013.

Benedict XVI. *Jesus, the Apostles and the Early Church*. San Francisco: Ignatius Press, 2007.

_____. *Jesus of Nazareth: The Infancy Narratives*. New York, Image Books, 2012.

Bruce, Frederick Fyvie. *Are the New Testament Documents Reliable?* London: Inter-Varsity, 1956.

Chrostowski, Waldemar. "Przbycie trzech króli", *Akademia Biblijna*, http://www.akademiabiblijna.pl/akademia,Teksty2,25.

Dodd, Charles Harold. *The Founder of Christianity*. New York: MacMillan, 1970.

Duquesne, Jacques. *Jesus: An Unconventional Biography*. Liguori, MO: Triumph Books, 1997.

Eusebius. *The History of the Church*. London: Penguin, 1989.

Firpo, Giulio. *Il problema cronologico della nascita di Gesù*. Brescia, Italy: Paideia 1983.

Glueck, Nelson. *Rivers in the Desert*. New York: Grove Press, 1959.

Guitton, Jean. *Gesù*. Leumann, Italy: Elle Di Ci, 1997.

Hague, Dyson. *Ways to Win: Thoughts and Suggestions with Regard to Personal Work for Christ*. London: Marshall Bros., 1896.

Hesemann, Michael. *Jesus von Nazareth: Archäologen auf den Spuren des Erlösers*. Augsburg, Germany: Sankt Ulrich Verlag, 2009.

Jaklewicz, Tomasz. "Święty Mateusz: wstali poszedł", *Gość Niedzielny* no. 38 (2005).

Josephus. *Jewish Antiquities*. London: Wordsworth, 2006.

Kasabuła, Tadeusz. "Kiedy narodził się Jezus Chrystus?" Opoka, http://www.opoka.org.pl/biblioteka/T/TB/kiedy_bn.html.

Keller, Werner. *The Bible as History*. New York: Bantam, 1983.

Lattes, Dante. *Apologia dell'ebraismo*. Palermo, Italy: Edizioni La Zisa, 2011.

Messori, Vittorio. *Jesus Hypotheses*. Strathfield, Australia: St. Pauls, 1978.

Occhieppo, Konradin Ferrari. *Der Stern von Bethlehem in astronomischer Sicht: Legende oder Tatsache?* Basel, Switzerland: Brunnen-Verlag, 1999.

Ratzinger, Joseph. *The Spirit of the Liturgy*. San Francisco: Ignatius Press, 2000.

Ricciotti, Giuseppppe. *Vita di Gesù Cristo*. Rome: Rizzoli, 1941.

Ruffin, C. Bernard. *The Twelve: The Lives of the Apostles after Calvary*. Huntington, IN: Our Sunday Visitor, 1984.

Seewald, Peter. *Jesus Christus: Die Biografie*. Munich: Pattloch-Verlag 2009.

Socci, Antonio. *Indagine su Gesù*. Rome: Rizzoli, 2008.

Thiede, Carsten Peter. *La nascita del cristianesimo*. Milan: Mondadori, 1999.

Photo credits

Polish edition: *Trzej Królowie, Dziesięć Tajemnic*
Published 2014 by Rosikon Press, Warsaw, Poland
© 2014 by Grzegorz Górny and Rosikon Press

English translation by James Savage-Hanford

© 2016 by Ignatius Press, San Francisco, and Rosikon Press, Warsaw
All rights reserved
ISBN 978-1-62164-131-5
Library of Congress Control Number 2016934527

This book has been produced with the support of the Three Kings Parade Foundation
(Fundacja Orszak Trzech Króli), www.orszak.org.

ORSZAK TRZECH KRÓLI